MW00634589

IMAGES
of America

OLD LYME, LYME, AND HADLYME

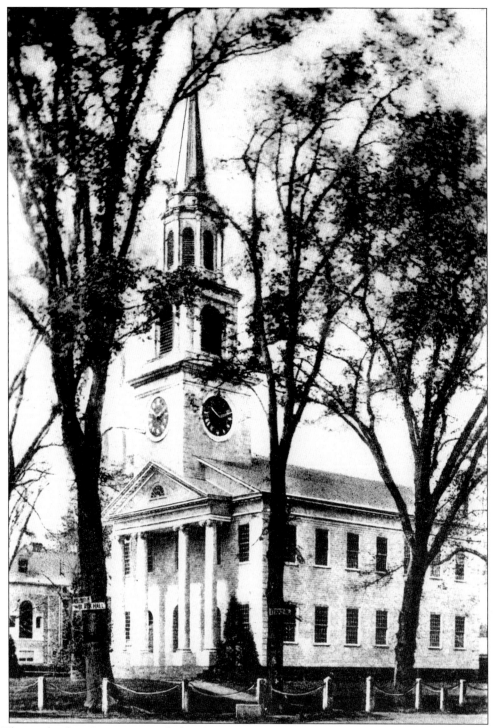

This is the first Congregational church on Lyme Street in Old Lyme. From a design by Sir Christopher Wren, it was built in 1817. It was destroyed by fire in 1907 and was later rebuilt. The church has been admired, photographed, sketched, and painted many, many times.

IMAGES
of America

OLD LYME, LYME, AND HADLYME

Kathryn Burton

ARCADIA

Copyright © 2003 by Kathryn Burton.
ISBN 0-7385-1315-6

First printed in 2003.

Published by Arcadia Publishing,
an imprint of Tempus Publishing Inc.
2A Cumberland Street
Charleston, SC 29401

Printed in Great Britain.

Library of Congress Catalog Card Number: 2003107526

For all general information, contact Arcadia Publishing:
Telephone 843-853-2070
Fax 843-853-0044
E-mail sales@arcadiapublishing.com

For customer service and orders:
Toll-free 1-888-313-2665

Visit us on the Internet at www.arcadiapublishing.com.

This book is dedicated to my best friend,

my husband, James L. Burton.

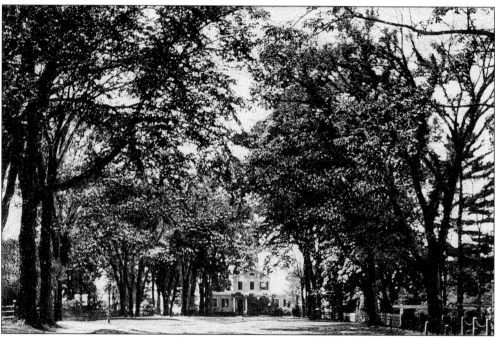

This is McCurdy's Corner in the summer of 1917. The peace and beauty are timeless and more poignant when one considers that the photograph was taken just a few months after the United States joined the Allies in World War I, "the war to end all wars."

CONTENTS

Introduction 7

1. The East Side of Lyme Street 9

2. Hamburg Cove, Joshuatown, and Brockway's Ferry 27

3. The Beaches and Black Hall 43

4. The West Side of Lyme Street 67

Acknowledgments 128

Bibliography 128

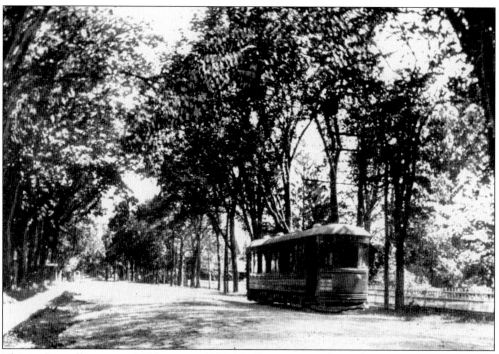

This is the trolley car in Old Lyme in 1920. Trolleys came early to the Lymes. A trolley track was on the first bridge crossing between Lyme and Saybrook. In its heyday, the Interurban (as it was called) ran from New Haven to New London. By connecting to other trolleys, a passenger could go from New York to Boston (which still has trolleys). Large-wheel paddleboats ferried passengers to the area from New York, New Haven, and Hartford. As late as 1931, steamboats came down the Connecticut River and went through the drawbridge opening to the delight of anyone seeing those last remnants of a time passing. Beginning in 1911, bridges were built over the Connecticut River to accommodate increasing numbers of automobiles. The Blue Star Memorial Bridge opened in 1941. These new bridges, along with the creation of better roads (such as Routes 9 and 95), broadened the horizon for people traveling to the area and brought change for the community.

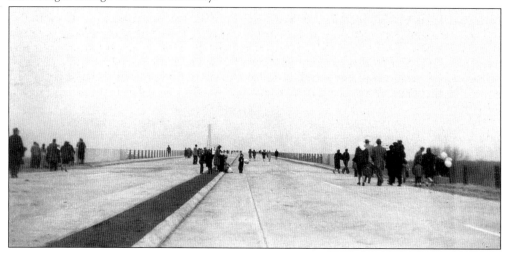

INTRODUCTION

The story of Lyme begins in Saybrook in 1639 with the arrival of 24 Englishmen looking for a safe harbor to use if the political scene in England required one. Col. George Fenwick was in charge and oversaw the plan to build a fort with comfortable accommodations for the families, in keeping with their station in life as men of means. Lion Gardiner was commissioned to design and build the fort at the mouth of the Connecticut River, where the river empties into the Long Island Sound. He soured on the plans for a town when the fort was attacked by a group of Pequot Indians, who had come into the area from upstate New York. The warlike Pequots had a profound impact on the history of the Connecticut region up to this day. The peaceful and friendly Nehantics lived here in small numbers for many years. Some moved to upstate New York, and some died. The last parcel of Nehantic property was sold at auction on Tuesday, June 4, 1867, at 1:00 p.m.

In 1644, with the political situation in England improving, the subscribers to the fort and to the plans for a town removed their funding. George Fenwick was forced to sell the fort to Connecticut, putting the Warwick grant lands from the Connecticut River to the Narragansett Bay under its jurisdiction.

Shortly thereafter, Fenwick's wife died and he decided to take his children back to England, where he would be a judge in the case against Charles I. Fenwick left his property on the east side of the Connecticut River to Matthew Griswold, a young man whose family had been known to him in England. Griswold named the area Lyme for his birthplace, Lyme Regis. By 1645, he was farming there. The area became a separate town in 1667, just one year after Rev. Moses Noyes had become pastor. He served his flock for 63 years until he died in 1729. The Noyes family played an important role in the history of the area and that of Yale University.

These circumstances, combined with the secular nature of the Saybrook settlers, created an unusual situation. The norm, under law, was that a church must be built before an area could be supported by the Colonial governor as a town. In this case, Lyme went through the process of becoming a settlement and establishing itself as a civil government before putting the ecclesiastical society (so much a part of the law and standard procedure) into place. This was done in 1693.

The actions of the community leaders were vital in the protection of Connecticut land from British power and allowed individuals to buy land outright from the town itself. Later, this helped the area make a clean break from the British. Other areas were encumbered by complex contracts and absentee ownership by our enemies in the Revolution.

All of the various "villages" that made up the early eastern side of the Connecticut River were originally called East Saybrook and later Black Hall. Then, Lyme, Hadlyme, Hamburg, Old Lyme, East Lyme, and South Lyme were divided. The properties were granted, bought, and sold. Churches were built, and the land was worked. Settlers continued to arrive until (both ecclesiastically and by law) separate towns were recognized, the last being Old Lyme. Even today, however, the old names hold in some places.

How some names of villages in the Lymes were changed is interesting. In *Lyme Yesterdays*, James Harding tells one story that focuses on Deacon Lodowick Bill. The good deacon was an energetic man with a true sense of self. His desire for public notice caused friction with the established families who ran everything. A division of the town was proposed by Bill and company. After much aggravation, the town fathers agreed to the split. Bill's sense of accomplishment was imperfect, however. He got his new town but lost the old name of Lyme. Therefore, the area of oldest settlement (but the newest separate town) became Old Lyme in 1857. (For a short time, it was even called South Lyme.)

Many of the old family names can still be heard in this area. A Griswold is once again first selectman in Old Lyme. In the fall, when the hills are full of color and empty of visitors, the towns become communities once again. Residents can still say that everyone knows everybody in town. Development, both industrial and residential, has been held at bay to a great extent (except in East Lyme, always a bit of a maverick). While the Lymes may not still be the home of more attorneys per capita than any other town in the country, the area is the home of a nationally known museum of art and an academy and college of fine arts. Everyone, no matter who, shares the knowledge that the Lymes are extraordinary.

One

THE EAST SIDE OF LYME STREET

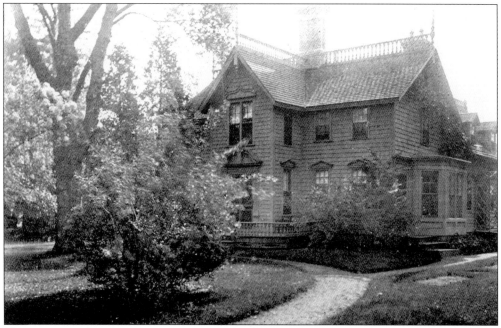

The images in this chapter are from a scrapbook created in 1978 by Susan Hollingsworth Ely. She was born in Old Lyme on Christmas Eve, and the nickname Holly fit her perfectly. She was a collector of information and was generous with it. She provided many people with facts and figures, but she also offered an inside history that only a lifetime resident could provide. While writing the beautiful book *The Lieutenant River* with her friends Elizabeth Plimpton, Stella Faulkner, Florence Knutson, Edna Lutz, and Arloa Tysse, she lost her sight, but that did not stop the publication. In 1986, she died knowing the first draft was finished. John and Werneth Noyes, her brother and sister-in-law, kindly provided the scrapbook. Seen in this view is the former home of Judge Charles J. McCurdy. It is located directly across Lyme Street from the Congregational church. The Marquis de Lafayette stayed here with John McCurdy during the American Revolution and came to call when he revisited in 1826. Local history says that George Washington accompanied Lafayette during the first stay in Old Lyme. John McCurdy distributed material promoting the Revolution and actively worked toward that end.

The Old Parson's Tavern stood next to the church. It was moved to a site behind Mrs. George Grant McCurdy's house and was renovated by Elsi Fergerson. In the rear garden stands the Whitfield Rock (right), from which the great English evangelist Rev. Henry Whitfield is reputed to have preached at one time. These photographs were taken in 1978.

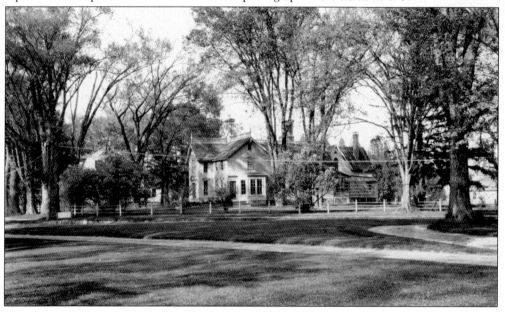

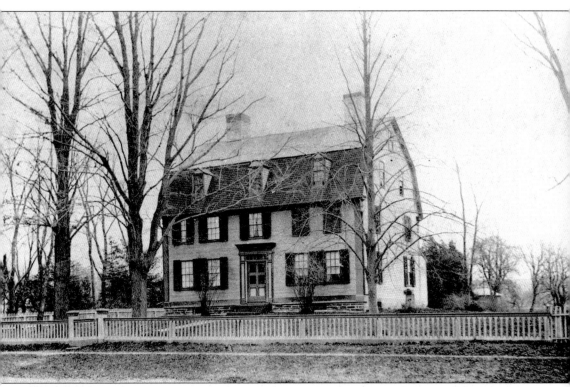

The Captain Samuel Mather House, located immediately north of the Old Parson's Tavern, is a gambrel-roofed structure. Presumably built when Mather was middle-aged, the house dates from *c.* 1784 (the year inscribed on a brick in the structure). It passed to his son James and then through a succession of owners, ending with Mrs. John Mather Chadwick, who bequeathed it to the First Congregational Church. Eleazer and Samuel Mather played an important role in bringing together the people of Lyme in June 1774. At that meeting, while the citizenry professed their allegiance to George III, they also voted to take reasonable measures "to relieve us and our brethren in Boston from the burthens now felt and secure us from the evils we fear will follow from the principles adopted by the British Parliament respecting the town of Boston." William Noyes and Samuel Mather were on the committee to keep towns advised as to the the development of the situation in Boston. They did, and Connecticut became known as the "provision state" in the war that followed.

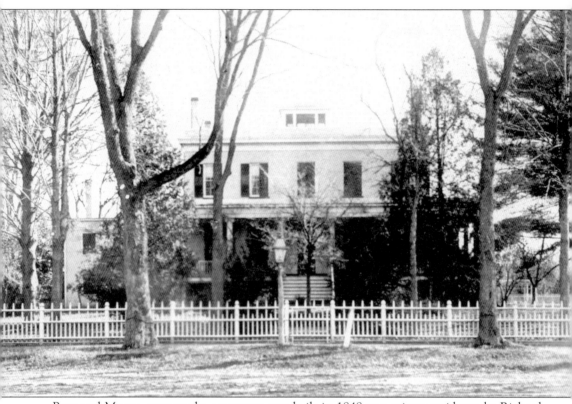

Boxwood Manor, next to the parsonage, was built in 1848 as a private residence by Richard Sill Griswold, a prominent shipping merchant of New York and Lyme. For a while, his wife conducted a girls' school on the property. It became a summer hotel when a third floor was added sometime *c.* 1920. In the late 1950s, it was converted to apartments by Dr. Matthew Griswold. Many of the old houses were converted into schools or hotels for summer residents, but recent history has seen an interest in reclaiming them through renovation into private homes.

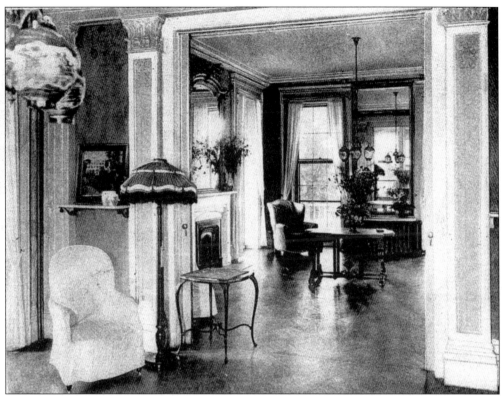

In any incarnation, Boxwood was beautiful, especially when the gardens were perfectly planned, manicured, and in bloom. The effect of these lush gardens must have appealed to the Impressionist painters who frequented Lyme. The young family below is out for a ride around the grounds.

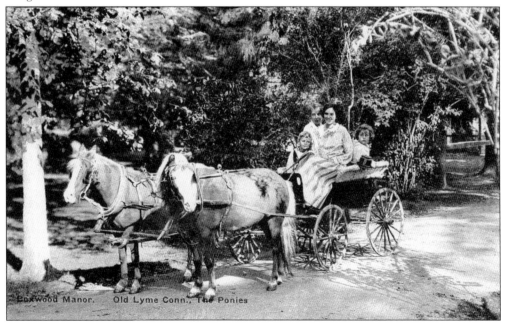

Boxwood Manor. Old Lyme Conn., The Ponies

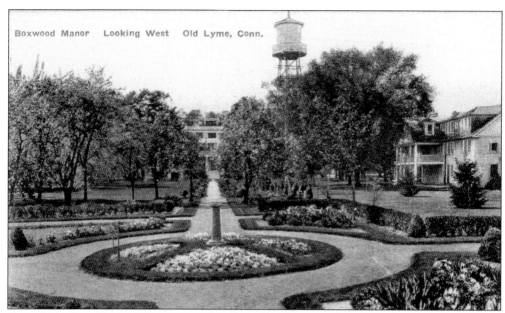

Boxwood Manor Looking West Old Lyme, Conn.

Everything about Boxwood Manor was lovely, although it must have taken a small army to keep it looking that way. This was a time when people of means would pack up and go to Europe for six months and "do the tour" in style. Henry James would have loved Boxwood as the essence of a particular lifestyle.

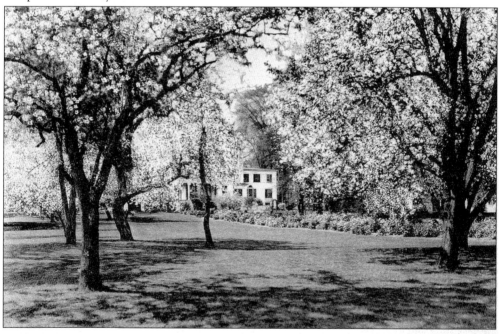

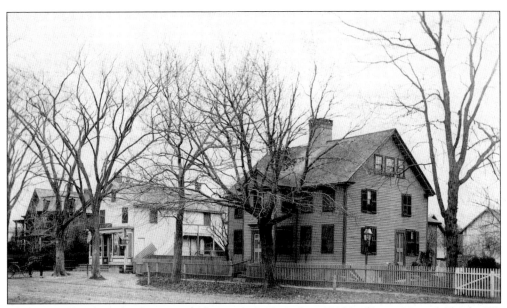

The tract of land north of Boxwood Manor was acquired in 1815 by Henry M. and Charles W. Waite. The latter built the house just south of Rowland's store. The post office was located in the house for many years, and Charles W. Waite and his son Gilbert served as postmasters. The Waite family included many well-known attorneys and judges, including Henry M. Waite (chief justice of the state supreme court) and Morrison R. Waite (chief justice of the U.S. Supreme Court). The Gen. Joseph Perkins house (above) was remodeled in the 1920s by Ethel Ely, wife of Williamson Ely. She saved only the original part, which she turned to face north. The original part was the home of Morrison R. Waite. Next to the Perkins house stands the Daniel Chadwick house (below), with its flat roof and captain's walk, dating from 1830. In 1978, the house was unaltered except for a 1905 enlargement of the second-story front rooms. Daniel Chadwick was renowned in both New York and London as a sea captain in the packet ship era. Members of the family still live in town.

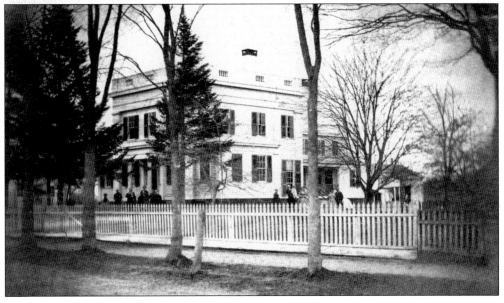

The Appleby house sits on the southeast corner of Library Lane. It was built c. 1782. The first district school stood on the north side of the property. The house below was built by Thomas Marvin, who was born in 1742. Marvin married Sarah Lay in 1784.

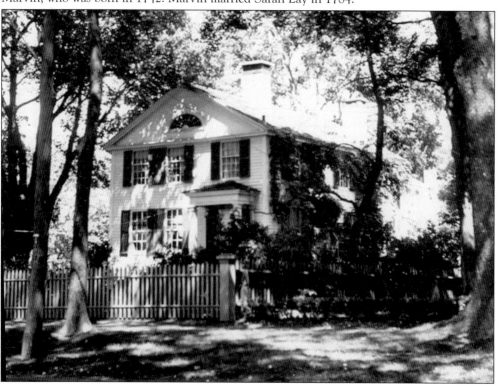

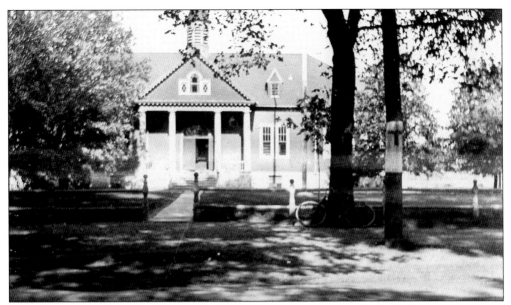

The Center School (above) was built in 1885 and demolished in 1934. Children of the town traveled to New London for high school. There was an all-boys school, an all-girls school, and a coeducational school. The New Center School (below) was built at a cost of $100,000 and was dedicated in 1935 by Gov. Wilbur L. Cross. The facade is of locally quarried pink granite. The other walls are of whitewashed brick. The single-story building encloses two large inner courts.

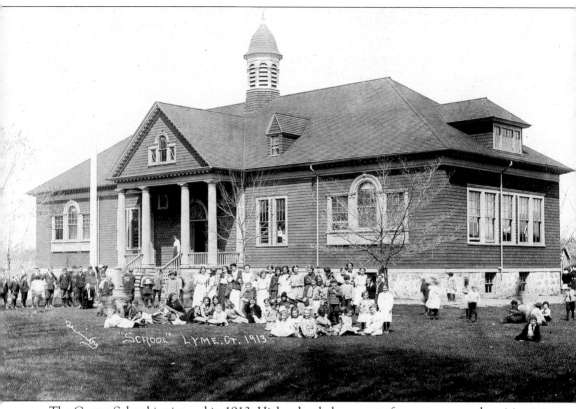

The Center School is pictured in 1913. High-school classes out of town may sound exciting to some youngsters, but these were the good old days, when the rooms were cold in the winter and hot in the spring. Subjects included reading, writing, math, foreign languages (Latin and Greek), social studies, geography, and English—all without computers. Schools, here and elsewhere, produced people who wrote great books, composed great music, and created great art and inventions, such as the computer. Rural and semirural schools had several class levels in a single room up until the 1920s.

John Huntley received a grant from the British crown for a home lot on July 12, 1666. A small home was probably built at that time. A typical sequence of ownership for Old Lyme houses can be seen in the record for the property. The first owner was John Huntley I. The house was then owned by Aaron Huntley (who inherited it in 1676), David Huntley (February 1723), Lewis Dewolf (July 18, 1739), Capt. Elisha Sheldon (February 10, 1740), Richard Mather (February 18, 1754), Elisha Sheldon (August 6, 1766), Joseph Marvin (March 26, 1768), and Joseph Lord Jr. (April 1, 1784). Joseph Lord Jr. was the grandson of Joseph Marvin.

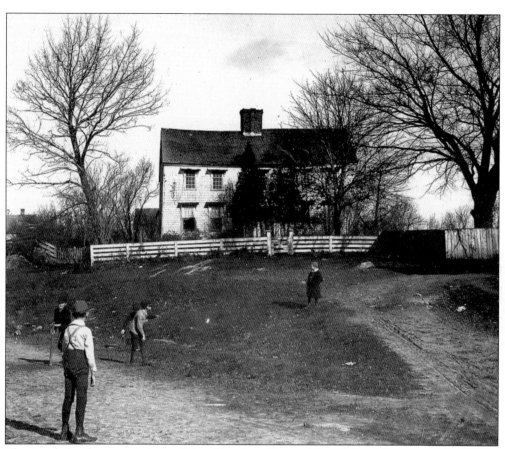

The Lord family occupied the John Huntley House (above) for 100 years. The house, demolished in 1898, was the birthplace of Phoebe Griffin Lord Noyes. The site, on the upper corner of Library Lane, is now occupied by the library (below) built in 1898 as a memorial to Phoebe Noyes.

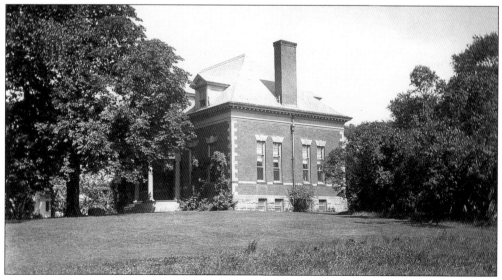

Phoebe Griffin Lord Noyes was a descendant of Matthew Griswold, who came to Connecticut at the time Col. George Fenwick was at Fort Saybrook. She was one of eight daughters born to Phoebe and Joseph Lord. The family lived on property inherited from her father's grandfather and was prosperous, with Joseph Lord leaving a large estate in 1812. Uncle George Lord offered to educate one of the eight girls in New York City, where his own daughter was being tutored in painting. Thus, young Phoebe Lord went to the city and developed a talent she had already explored. When she returned to Lyme, she used this talent to help support her large family through teaching and tutoring. On May 16, 1827, she and Daniel Rogers Noyes of Westerly, Rhode Island, were married in the Congregational church in Lyme. She spent a lifetime of service to Lyme, touching many lives and opening the eyes and minds of many children, including her own six. She died in 1875, and her husband died in 1877. The library (above) was dedicated in 1898, with hundreds in attendance.

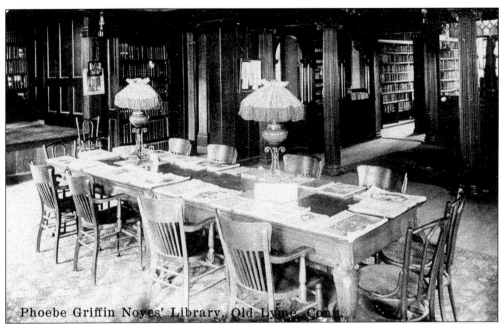

Phoebe Griffin Noyes' Library, Old Lyme, Conn.

The beautiful woods and workmanship in the interior rooms add a bit of formality to the library, but many people's favorite spot is the cellar, where book sales are held. The sale at Christmas is well attended by people seeking inexpensive, hard-to-find books. Funds go to the library. Earlier photographs of the Phoebe Griffin Noyes Library show the site with very young trees and shrubs. Today, the trees and shrubs are fully grown, creating a private and inviting place. A popular bumper in town sticker reads, "Everyone loves Phoebe."

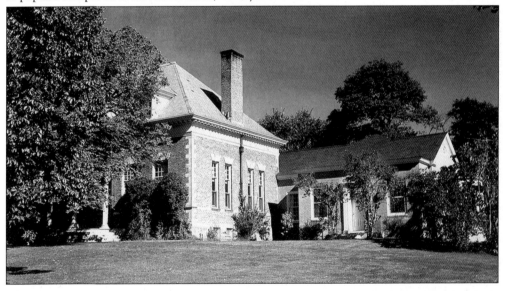

This Native American mortar stands on the front lawn of the library. It was used by the Nehantic Indians as a corn mill. The historic artifact was found on the Dennison Farm, on Four Mile River Road; for many years, it stood near the well sweep at the Guy Chadwick house, on the same road. It was brought to the library *c.* 1898 on a stone-drag drawn by oxen. The Whipp house (below) was built *c.* 1840. The original portion was formerly the ell of the Congregational parsonage. The people of that time were the first true recyclers, using parts of old houses in new ones, often very successfully.

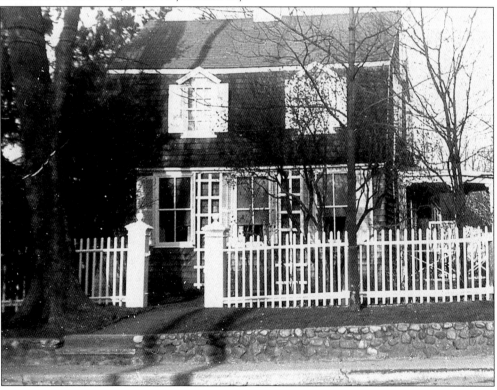

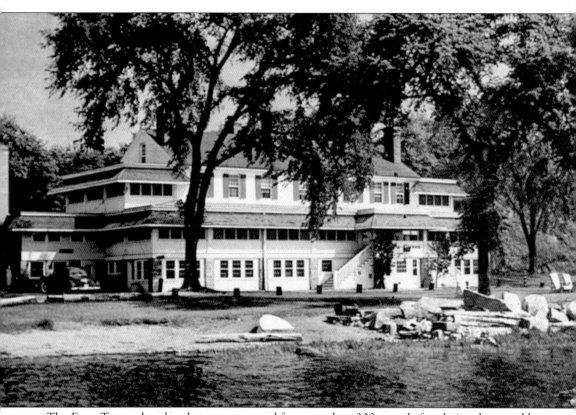

The Ferry Tavern hotel and restaurant stood for more than 300 years before being destroyed by fire in February 1971. The structure began as the private home of Capt. Matthew Bacon, who was given a grant of land by the king of England. It was eventually turned into an inn for pre–Revolutionary War travelers. It stood at the terminus of the stagecoach route on the old Boston Post Road before the railroad was built. Among the more illustrious previous owners of the Ferry Tavern was Cornelius Vanderbilt, who owned it and a steamship line in conjunction with Matthew Bacon in the 1800s. It became very popular with people who came up from New York for the fishing. The structure was built, as many buildings were at the time, by shipwright carpenters. The rafters and massive supports were hand-hewn oak, held together with oak pegs. Bricks for the chimneys and interior side walls had come over as ballast on British ships. The estimated loss of the 22,000-square-foot building, which contained many antiques, was $400,000. Of course, the antiques were irreplaceable.

The road to the Lyme ferry was a pleasant one. Although the people (below) look cold and uncomfortable, the ferry from Lyme to Saybrook was welcomed by locals, who previously had to travel more than three hours upriver to get a ferry. People walked across farmland to the closest roads; there were no official landing areas. The first bridge here opened in 1911.

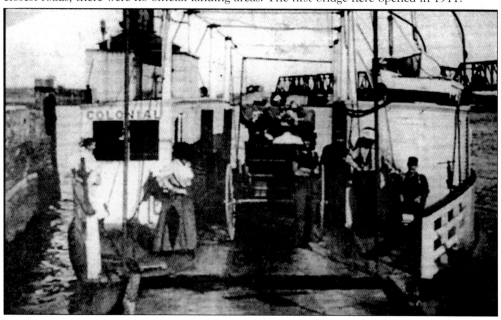

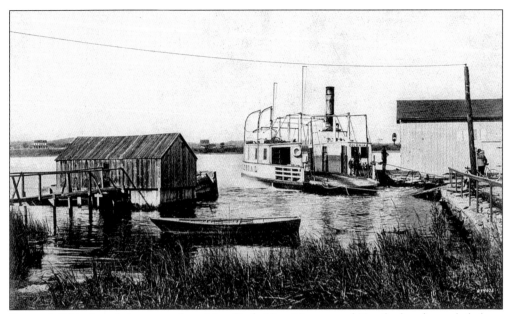

Boats of all kinds and sizes came from New York, New Haven, and Hartford and traveled along the coast and up the Connecticut River. Ferries ranged from small sloops (early on) to large paddleboats. The only ferry in the Lyme area at present is the one that runs during the summer months between Hadlyme and Chester.

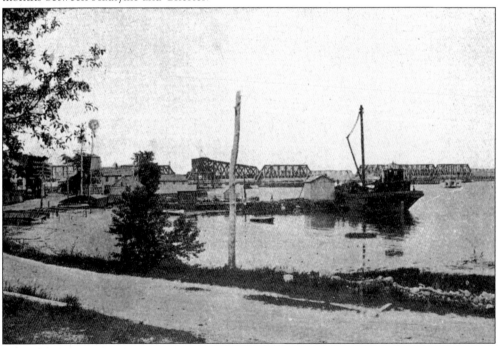

Two

HAMBURG COVE,
JOSHUATOWN, AND
BROCKWAY'S FERRY

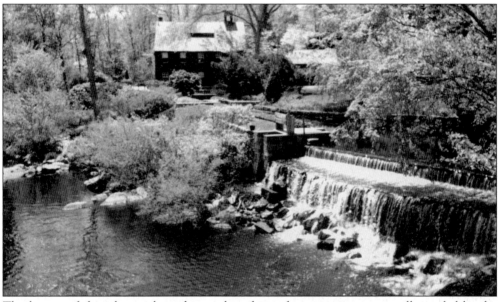

The beauty of this place is legendary and unchanged to a great extent, still guarded by the residents, town zoning, and Mother Nature. Not "gentrified," the area maintains a slightly rough but always interesting look. The posted speed limit of 25 miles per hour is carefully enforced, if not by the locals, by the terrain; rolling hills and sharp curves are the traffic cops. The beautiful Mill House is on the Eight Mile River near the cove. The cove is all about boats, boating, and people. Times change, but there is a certain stability about the comings and goings here. In a few weeks time, like an open field where flowers spring up overnight, the cove becomes busy on the weekends. Shortly afterward, it becomes busy during the week, too, with hundreds of boats coming and going. Stanley Schuler's book *Hamburg Cove* details the kinds and sizes of boats that frequent the cove. The book also explores some of the cove's annual events and offers a wonderful description of summer life here.

Early on, people saw only the good side of automobile travel. They soon learned, however, that there was a price to pay when country roads produced broken axles and flat tires. Nevertheless, automobiles brought freedom to the whole family. Telephones were being introduced everywhere, too, but service might include being on a party line, which meant waiting until the neighbors were finished to make a call. Local phone numbers were simple then: there were no area codes or even local codes—just a two-digit number. A telephone in the car? Not in those days—just a quiet drive across a country bridge into Hamburg.

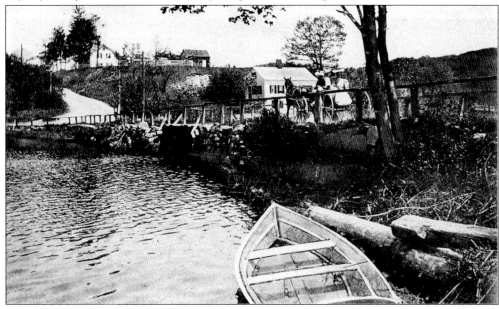

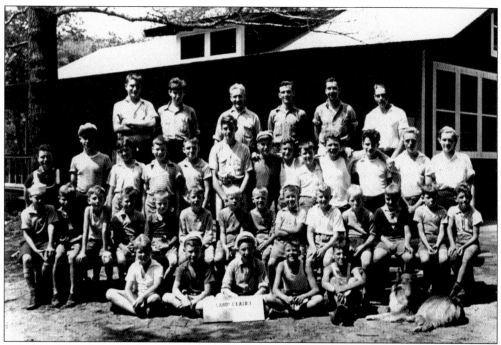

Camp Claire was the dream of Philip Cowell Jones, the youth director for the First Congregational Church in Meriden in 1915. Jones wanted to create a summer overnight camping experience for teenage boys. According to church historian Mark L. Hamilton, by 1916, boys attended the campouts on the Sawyer Farm in Hamburg Cove in July, and girls did the same in August. The camp was originally called Camp Congo. In 1936, Arthur S. Lane of Meriden purchased 10 acres and donated it to the church, with the stipulation that the property would be called Camp Claire in honor of his wife. Over the years, countless children have gained a lasting appreciation of the outdoors, learned new skills, and formed friendships at the camp.

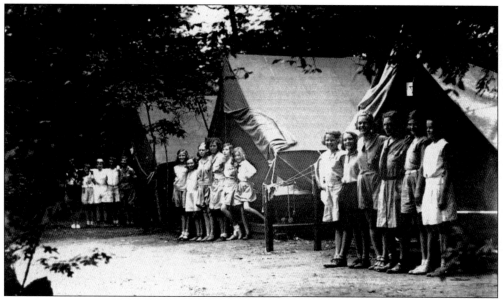

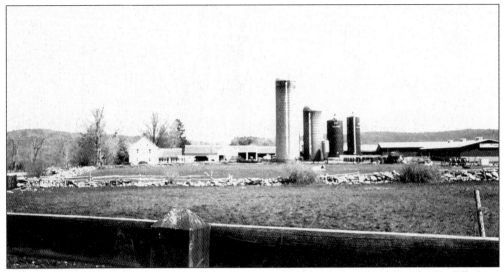

Along the way from Old Lyme to Hamburg on Route 156 are many very old but beautifully kept homes. One in particular, a stone house, has been restored after a serious fire. It is testimony that such beautiful stonework is still being done. The Tiffany Farm (seen here) was first owned by the Selden family in 1741 and was bought by Charles E. Tiffany in 1841. It has been photographed many times, and the area's children have grown up going to see the cows. A "Ladies in Waiting" sign is posted an area where the pregnant cows munch the day away in the pasture.

Sterling City Road is off Route 156 in front of the Tiffany Farm. In the early 1700s, the area was the site of lumber, grist, cider, and textile mills. The small community was founded by Capt. Daniel Sterling in 1709. The Sterling, Ely, Otis, Harding, and Sill names were part of the history of this area. The community has maintained its charm and quiet nature—and likely will continue to do so as long as the Tiffany Farm survives.

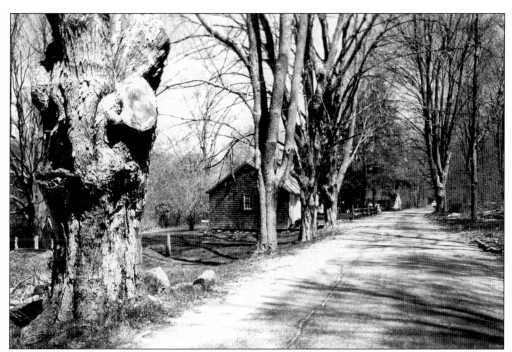

In the mid-1600s, Saybrook experienced an exodus as a result of the opening of the Lyme area for settlement. The familiar family names—Griswold, Marvin, Peck, Lay, Lee, and Lord—may be seen throughout the legal papers of those days, forming and regulating what would become a town in name and actuality. Of course, anyone with a skill was welcomed with a proviso that the newcomer be given a piece of land on which to live. He had five years to prove his value to the town before the deed was given. Some came to the Sterling City area, and there are many early homes still standing. A local conservator has moved old homes from other areas to this place, and they look as though they had always been on the site. If houses could be happy, these would be.

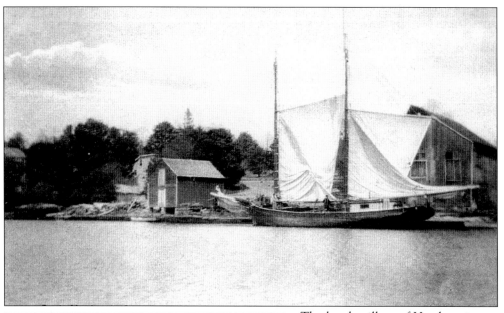

The lovely village of Hamburg is more marina and cove than actual town, with a nationally known antiques shop, a foreign car dealership, a church, and a general store that has been in business continuously since 1859. Jane DeWolf (left) has been proprietor of the Reynolds store since 1953. She knows everything about the cove and can be found daily at the store. The cove is a safe harbor during storms and can take large pleasure boats. Very early in Lyme's history, when this area was known as North Lyme, there were mills that used both the streams and lakes here and then shipped their wares from the cove.

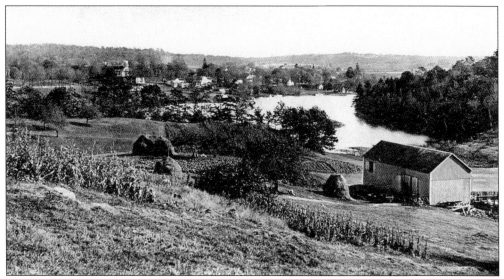

Czikowsky's Hill overlooks the Upper Bay of the cove and has a glorious view, often immortalized by artists and photographers of all talents and capabilities. It is nearly impossible to take a bad picture of the view. Timeless, expansive, and full of charm, it is beautiful in any season on Joshuatown Road in Hamburg. The Czikowskys, hardworking farmers, had a store and a horse-drawn wagon that carried meat and produce to their wholesale customers in Norwich every day. Both Eugene and Annie Czikowsky were born in Prussia and died in 1944.

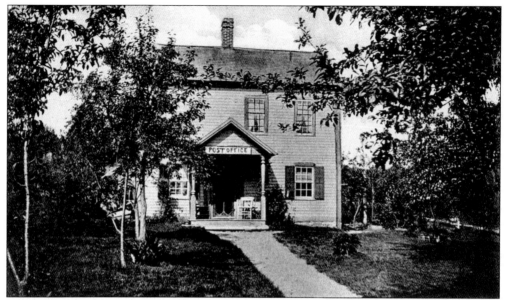

This little post office was in the private home of the Huntley family in Hamburg. Such post offices could also be found in stores up until World War I and may have continued longer in some areas. Hadlyme Ferry Landing was a bare-bones operation, but people were very glad to have it.

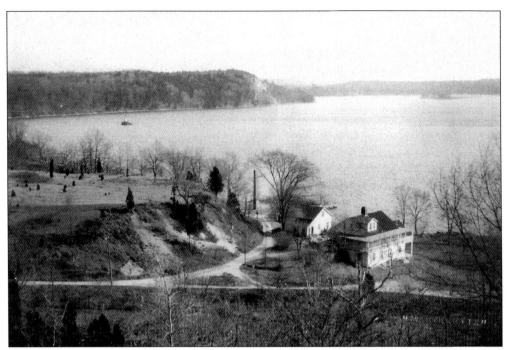

Elizabeth Huey Putnam was born at Brockway's Ferry, on the banks of the Connecticut River, in 1912. That was a year after the opening of the first bridge to Saybrook from Lyme. It was prior to World War I, and Lyme had remained comparatively untouched by such major happenings. Wolston Brockway bought this 40-acre lot from Rev. Moses Noyes in 1702. It lies within the section called Joshuatown. The area was named for Joshua (a son of the Uncas, the Indian chief), who had owned it. After the death of Joshua, it was settled by Richard Ely. Many people have called this place one of the most beautiful village areas in the country because of its rolling hills and its abundance of springs, lakes, ponds, and rivers. Elizabeth Huey Putnam remembers when cars drove across to Deep River on the ice, which was more than 16 inches thick. While it sounds like fun, it was sometimes necessary in the days before the ferries. Even walking was a trial, especially for children, who did not have school buses pick them up. The Brockway schoolhouse was only about a mile away, but it was uphill.

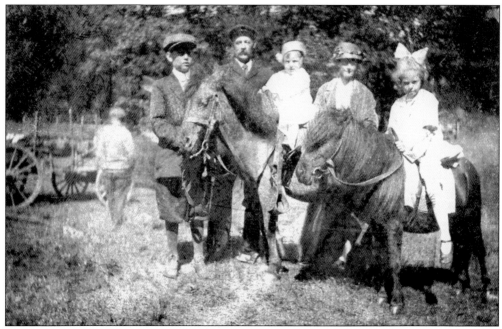

Elizabeth Huey Putnam is pictured above as a baby with her father, mother, and older sister. The young man on the left is not identified. They are at the Hamburg Fair almost 90 years ago. The annual fair is still going strong. Below is the graduating class of the Brockway School in 1924. From left to right are Leland Reynolds, Doris Reynolds Jewett, Pearl Coltson, Sylvia Daniels Harding, and Elizabeth Putnam, who went on to teach at the Brockway School, the Lyme School, and the Essex School. She has been honored by the town of Lyme and is viewed as one of Connecticut's living treasures.

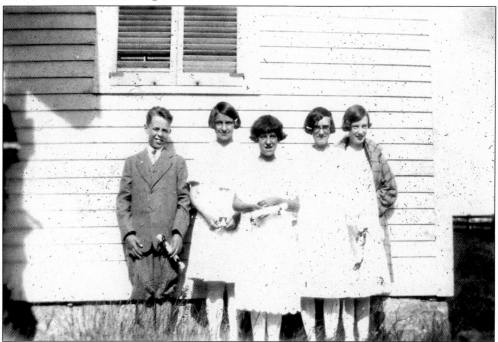

Robert Huey (right) is shown holding a shad. These fish used to be plentiful in the Connecticut River, and various programs have tried to bring them back. In 2003, the shad was named the state fish. Sturgeon (below) also ran in the river and were of value for their caviar. A check for more than $230 was the prize for a single fish laden with eggs. A man from New York City came to Brockway's Ferry to pick it up and to deliver payment. Sturgeon are not found in the river today.

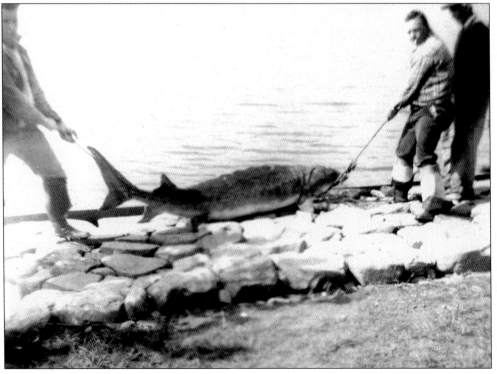

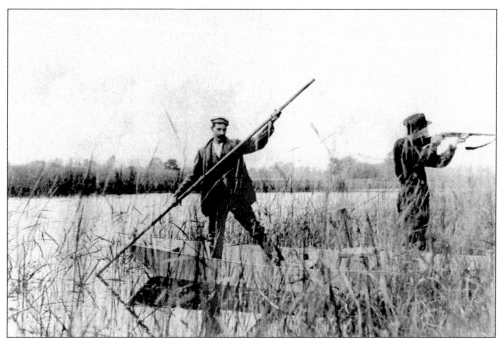

When Elizabeth Huey married Russell Putnam, the couple moved into a house built by her father, Robert Huey, south of its present site. Her father had to put it onto rollers, move it onto a scow, and float it to her dock next to the family homestead. There, he rolled it onto its new site, proving his motto: "You can do anything if you stop to think how it is done." During the 1938 floods, a rope attached through the upstairs windows was secured to the Ocum chimney, which was damaged and had to be taken down. The chimney bricks were used to make a very nice retaining wall on the hill behind the house.

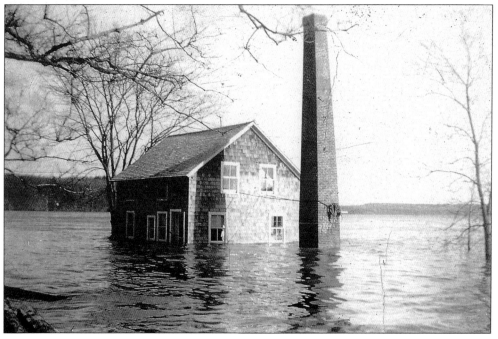

Robert Huey, father of Elizabeth Huey Putnam (below), was a blacksmith, quarryman, fisherman, hunter, carpenter, boatbuilder, and house mover. He did beautiful stonecutting, a skill that he learned in Pennsylvania—one which brought him to Connecticut. He also kept a small building for blacksmithing. Samples of his other works may be seen everywhere on the property. The house that he built for his daughter and then moved onto its present site stood through the hurricane and floods of 1938—a testimony to craftsmanship and quality. His daughter is particularly proud of the beautiful fireplace, the patio (made with old post office stairs), and the handsome chimney on the side of the house.

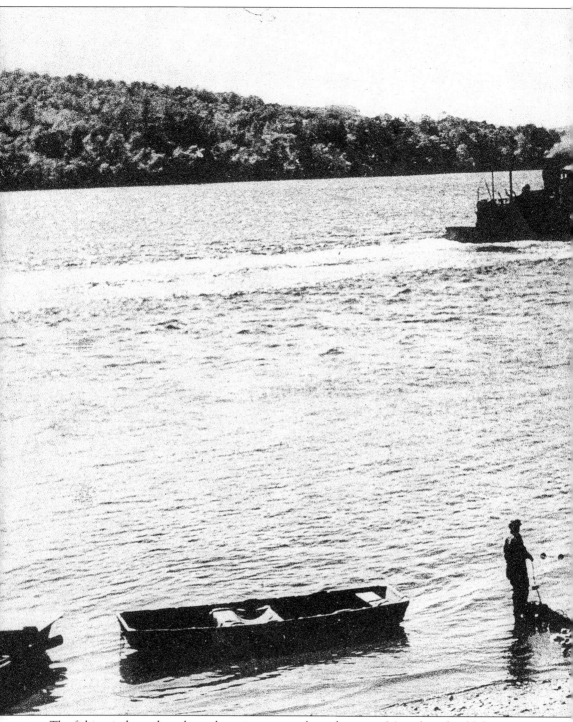

The fishing industry has always been important along the coast. Many barrels of fish were sent off to markets in Hartford and all over the East. Elizabeth Putnam said that when she was a child, her father would bring in the nets twice a night, something not done in many years. The fishing industry has fallen on comparatively hard times because of a lack of knowledge early on

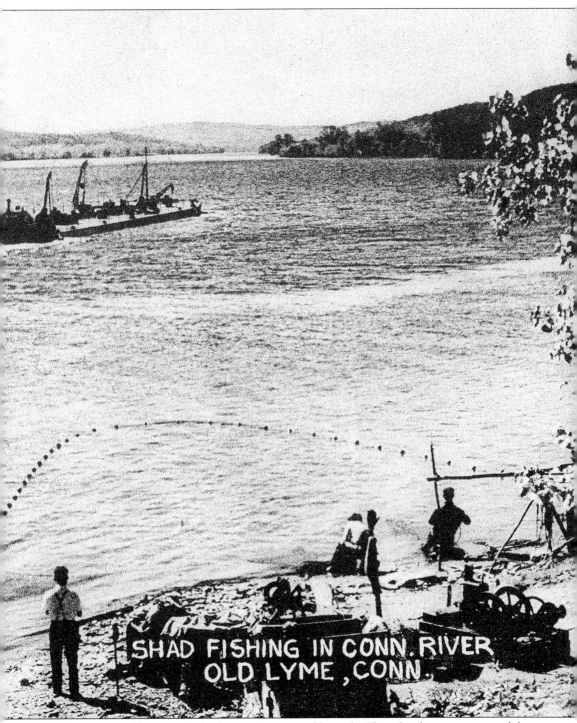

SHAD FISHING IN CONN. RIVER
OLD LYME, CONN.

about the impact of dumping and other environmental hazards. There has been a return to fish farming under controlled conditions. In this area, most of the fish farming is done for the Pequot Indian commercial ventures. The large seines can present a problem for boats and must be handled very carefully in such a busy water area.

Tantummaheag has always been one on the most beautiful areas in the Lymes, offering an expansive view from the mouth of the Connecticut River, down to the Sound, and beyond. It abounds in bird life. The boys below are serious fishermen and boatmen. They grew up as familiar with boats and the outdoors as today's youngsters are with skateboarding and video games.

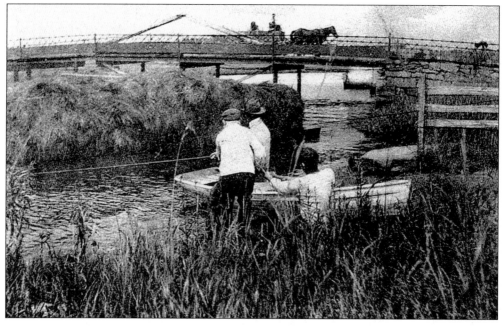

Three

THE BEACHES AND BLACK HALL

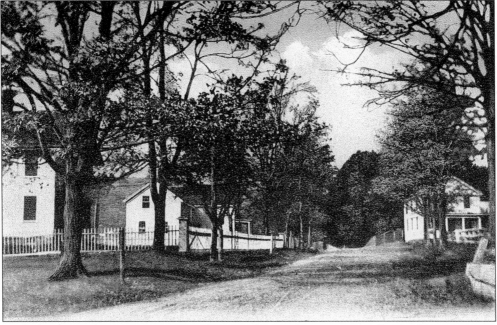

With this view of Main Street in Hamburg, we leave what was originally North Lyme. Route 156 has long been a connector to East Haddam, Salem, and Colchester. The way back into Lyme passes Hamburg, the Lyme Town Hall, the Tiffany Farm, Nehantic State Park, many lovely old homes and barns, and the Boston Post Road in Old Lyme. The road continues until it becomes the Shore Road, traveling east through the beach areas of Sound View, Point O'Woods, and South Lyme before reaching Niantic. In the 1600s, all of these areas were known as Lyme at some point.

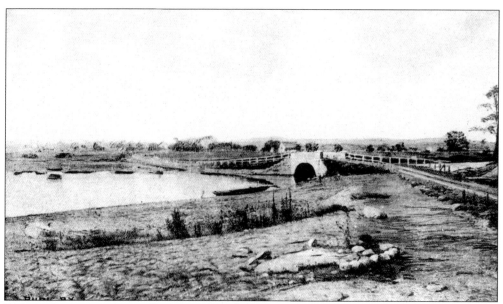

Early bridges across the small rivers and many streams were usually made of wood; some were made of stone. The Bow Bridge, across the Lieutenant River, is the area's most famous wooden bridge because it was drawn, painted, and engraved into immortality. Just under 70 feet long and 16 feet wide, it is not only romantic and charming but also useful. It was replaced in 1928 by a steel bridge, which was replaced in 1941 by a three-span steel-girder bridge. Below, the farmers behind a horse-drawn plow display a scene common to Lyme 100 years ago; however, this photograph was taken in the spring of 2003.

The Chadwick well sweep, a South Lyme landmark, was easily identifiable and a welcome sight for travelers. In the 1660s, Thomas Lee built a house in that area, settled, and had 15 children. He and his wife were leaders in the community and owned property as far away as Salem. The Lee house (below) still stands on Route 156 in the Four Mile River area. Alongside is the Little Boston School House, and in the barn is a very good display of material from America's first submarine, the *Turtle*, which played a role in the Revolutionary War. A Thomas Lee descendant operated the submarine under orders from Gen. George Washington.

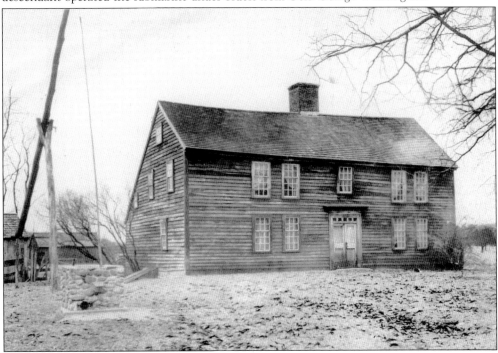

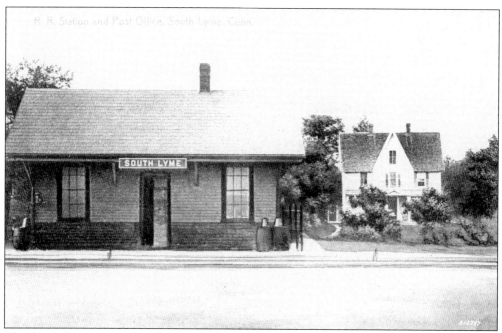

The South Lyme post office does not deliver the mail; it holds it in post boxes and is a great convenience for summer residents who have letters sent on from home. It has its own zip code, sells stamps, and sends letters out. The beach area is shown below off-season, still an inviting place to go for a walk. The view looks toward the point from Massachusetts Road in South Lyme.

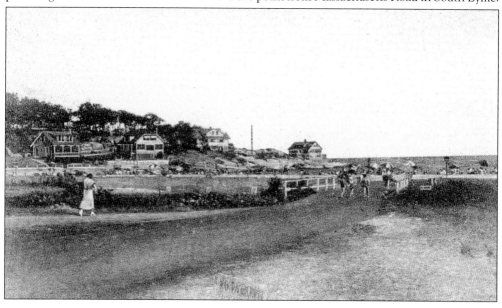

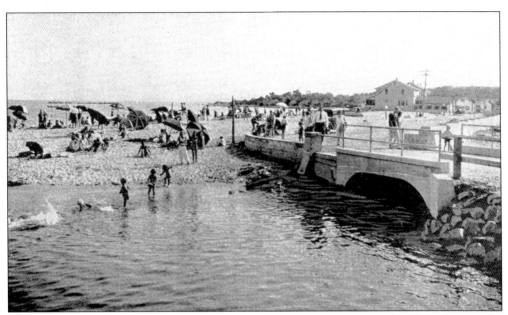

These two pictures are of Point O'Woods, in South Lyme. The man in the white shirt on the left side of the bridge seems to be the father, here to pick up his children. The children below are in their own world—unencumbered by adults, making their own fun, investigating everything, developing their learning skills without knowing they are doing so, and having a great time. These views epitomize the freedom of life at the shore.

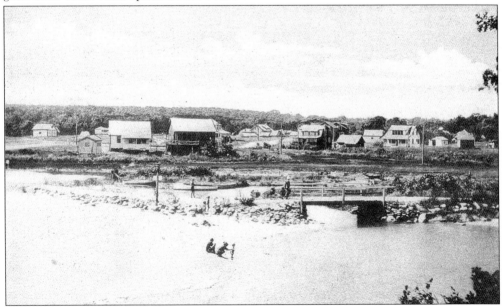

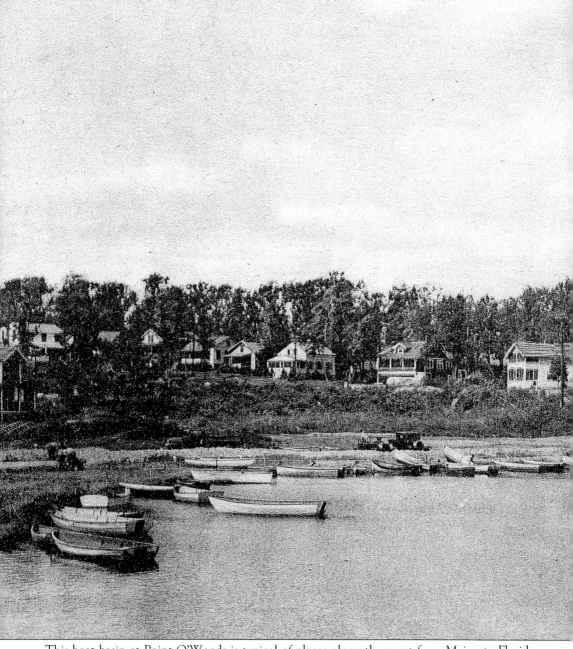

This boat basin at Point O'Woods is typical of places along the coast from Maine to Florida, the major differences being the rockiness and types of vegetation. It offers boating, swimming, fishing, or just sitting under an umbrella with a good summer novel. At one time, what is now the Sound was a freshwater lake, with no connection to the Atlantic Ocean. Through a very long time, an opening evolved and created Long Island Sound. Today, there are still freshwater

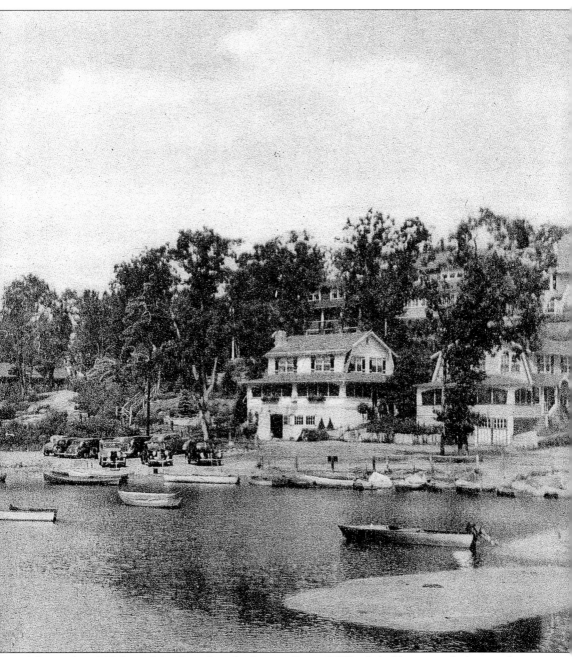

lakes within 100 feet of the Sound in the Lymes. Point O'Woods holds a special place in the minds of many families whose children grew up there and whose memories revolve around those wonderful summer days. It has, however, changed. The houses that seemed so large years ago are being dwarfed by new, larger ones in gentrified communities along the coast. Perhaps someone 100 years from now will be writing of the charm these new houses held.

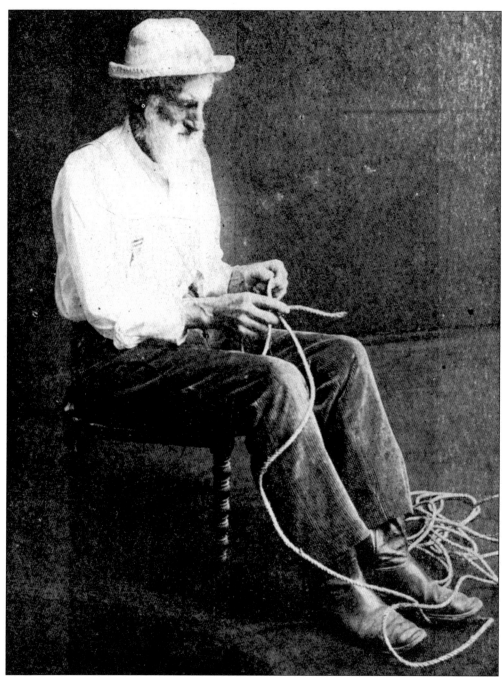

This sailor is making knots, a small but valuable talent that has for the most part disappeared from life in general. On the boats of the past, however, such knots were a vital part of fishing and sailing. They saved lives and made work easier. Young boys would start learning the craft very early in life if they wanted a career on the sea. Some of the nets cast in commercial fishing today are huge, and most are made by machine. In the old days, the seines would be pulled up at the end of the trip to be examined and repaired by hand. These people obviously had no need to go to the gym.

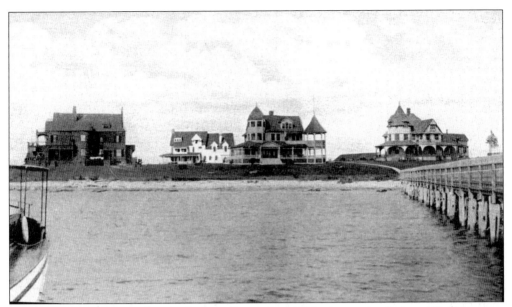

Hatchett's Point, an upscale area, had smaller versions of the impressive "cottages" of Newport, Rhode Island. Many of the families who summered there came from New York, Hartford, or Springfield, Massachusetts. Its position, jutting out into the Sound, afforded privacy and access to boating.

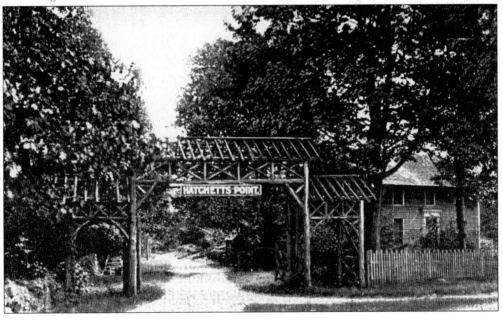

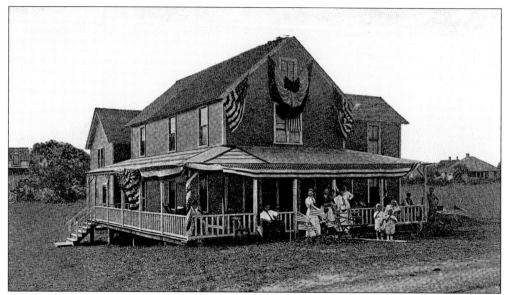

Point O'Woods was a self-sufficient community with its own stores, restaurants, and hotels. Many people came down from Hartford or even Springfield, Massachusetts, for weeks or a whole summer. As in many such beach areas, a real community spirit was developed. Lifelong friendships were made, and a lot of fun was had. Boxwood Manor (below) was a favorite place to enjoy a day at the beach. Locals, oddly enough, did not swim much until late in the 1930s.

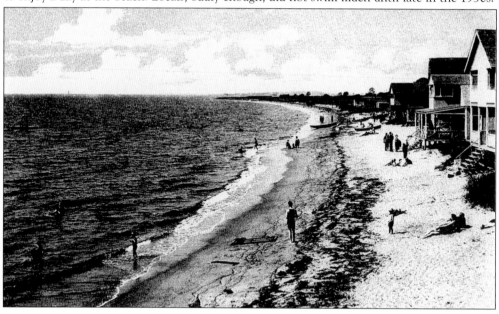

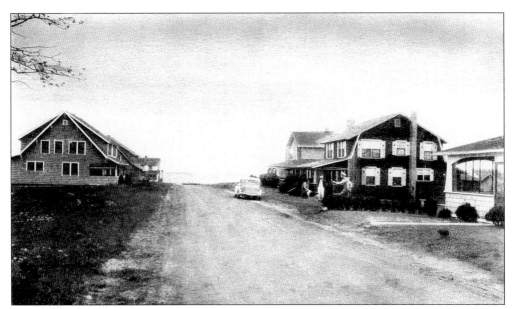

This 1930s view of White Sand Beach shows Springfield Road in Old Lyme. Looking like a regular community that happens to be on the shore, this area was a family place. Connecticut is not one of the first areas people mention when they talk about great swimming, but boating is another matter. This area at the base of the Connecticut River, protected on the Sound by Long Island, is known everywhere for boating.

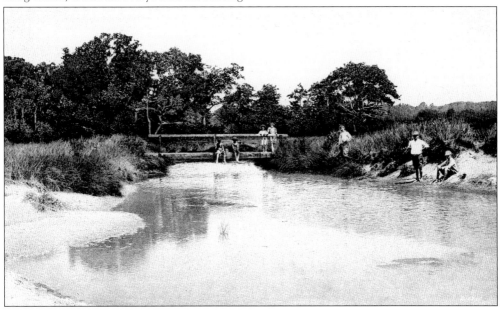

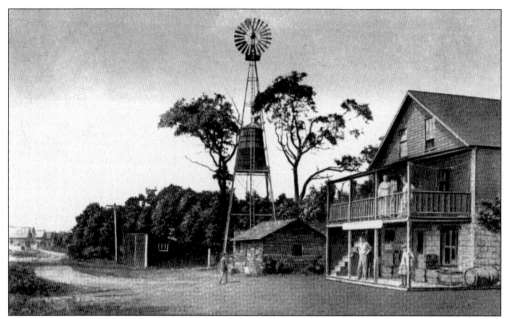

This view shows the Hawks Nest house and shop. Shopping carts (below) were common sights in the city but also offered wares from fruits and vegetables to clothing and household goods anywhere there were people. This one, at Sound View, was a familiar sight, and everyone looked even if they did not buy.

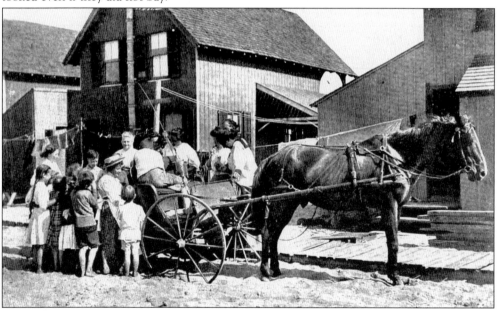

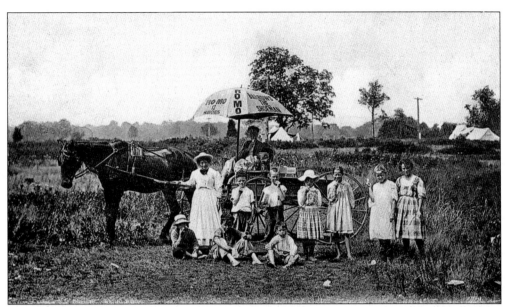

Just why there is a shoe company sign on that umbrella (above) is uncertain, but the children seem to have flocked to it. Life at the beach was low-key fun most of the time, and vendors such as this one were a bit of excitement even for adults. Soundview Casino is shown in the 1930s. Casinos were usually places where dances were held and entertainment was offered, but big-name stars did not appear—just talented folks having fun. The word casino has a different connotation in Connecticut today.

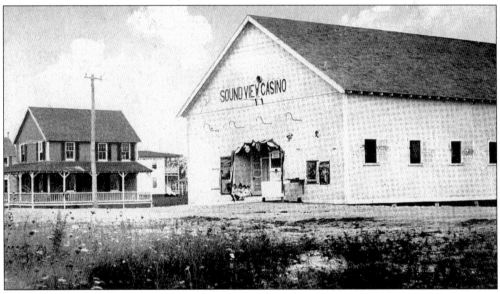

WHERE YOU MEET YOUR FRIENDS AT SOUND VIEW, CONN.

In the summertime Sound View drew people who owned homes here, rented places, or visited. Many came just on weekends, except for those glorious two-week vacations. "Where your friends meet" was not just an advertising slogan; it was fact. People looked forward to getting together to hear about what they were missing back home in the city. Until recently, these homes were not winterized. Now, many are being converted to year-round residences, and there are plans for a new hotel.

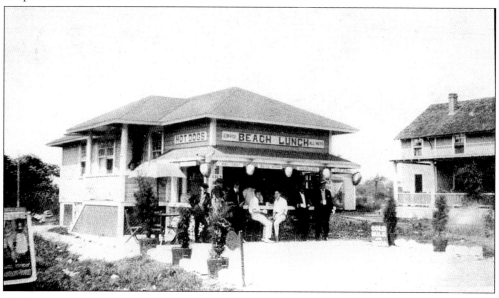

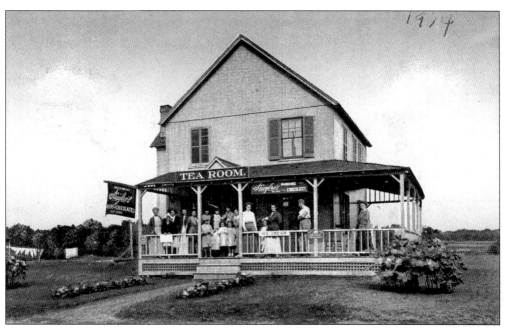

Even people who stayed at the small beach houses wanted a place to go for something a little nicer than the fare at a hot dog stand. The Tea Room (above) answered that need and was very popular. In fact, any place that offered food was popular, with few houses having a full kitchen and the cooks trying to stay "on vacation." Lyon's Cottage (below) was typical of the boarding places of the time. These were used by weekenders or by visitors for short stays—if they could find an opening.

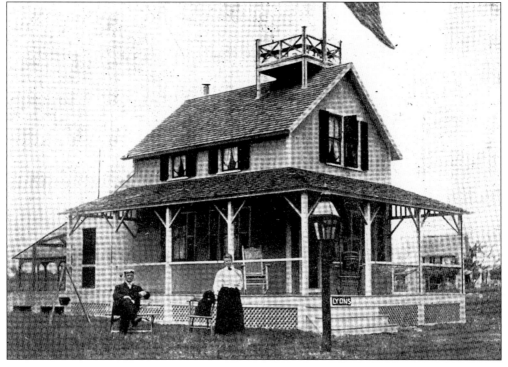

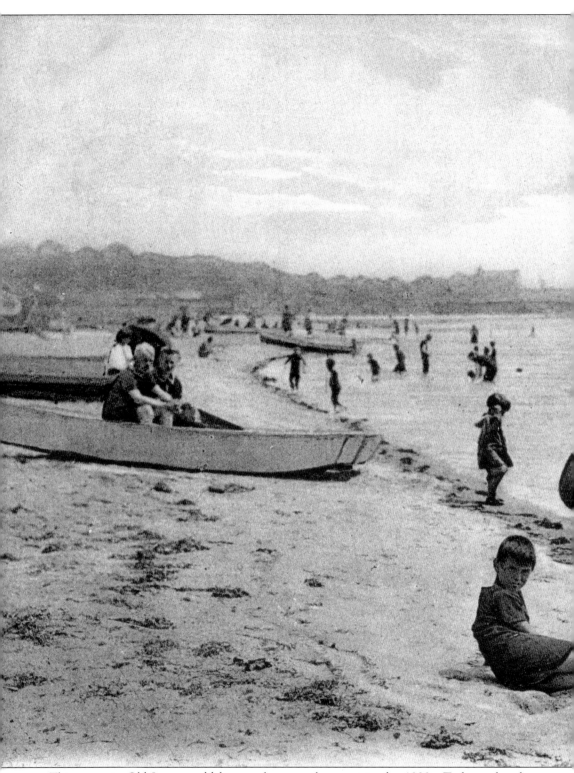

This scene in Old Lyme could be anywhere on the coast in the 1930s. Today, a beach as

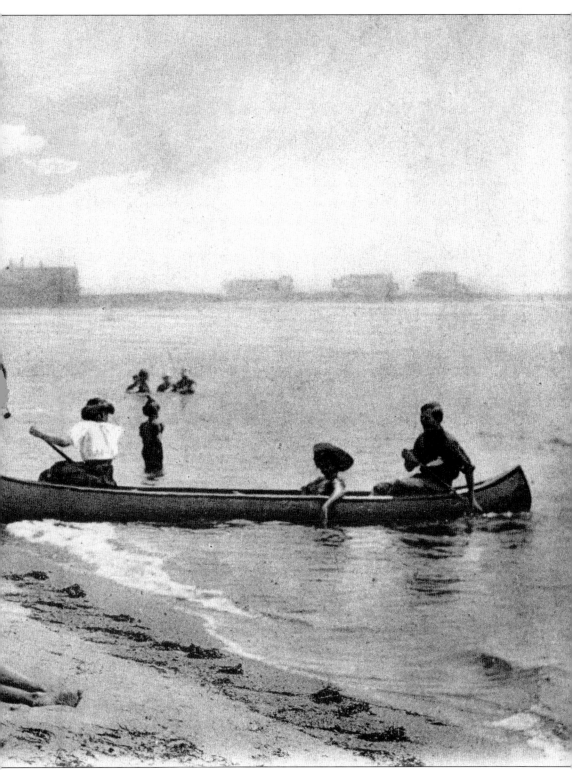

uncrowded as Sound View is indeed a rarity.

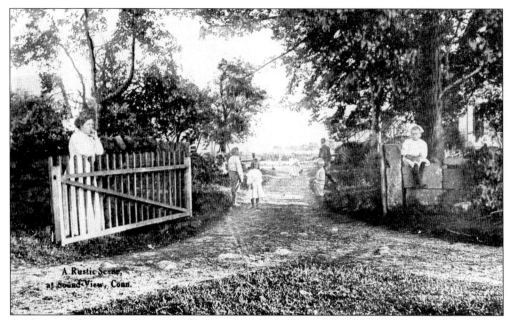

A Rustic Scene, at Sound View, Conn.

At the time these images were made, most people did not fly, but everyone wanted to get away for some fresh air. Some opted for the mountains and enjoyed the lakes. Places like Atlantic City, New Jersey (before the casinos), created an interest in the seashore, and the development of the state park system was like a magnet to families who suddenly saw the opportunity to get the family out of the cities and into the natural world, away from telephones and crowds.

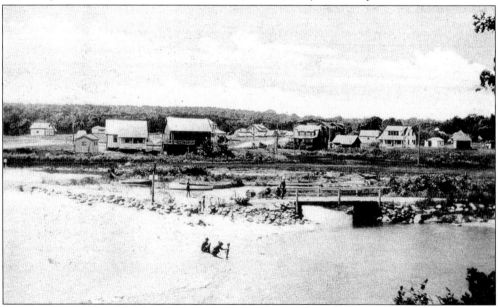

The summer population provided tax money and income to local businesses, but it also created jobs for everyone from high-school delivery boys to grandmothers who baby-sat for visiting families. Most of the local farm youngsters had their own work to do and did not get to the beach often. Church groups had picnics, however, and several generations spent the day together. The stores at Point O'Woods and Sound View came in handy for these outings. The beach areas inspired hotels, restaurants, and all kinds of service businesses. The overflow created other businesses nearby, farther inland. Boxwood Manor (below) was a group of cabins right on the shoreline. They were usually rented for the season.

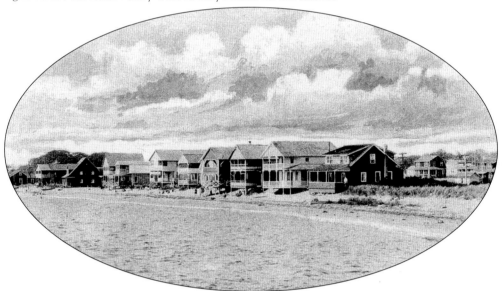

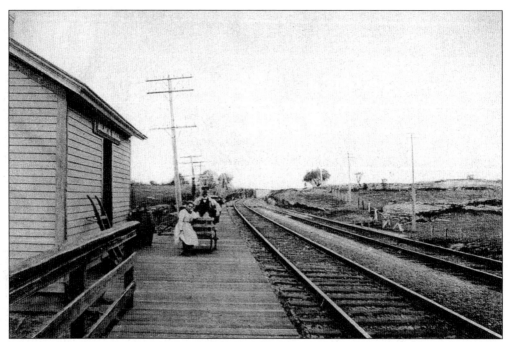

This view of the railroad station at Black Point gives no hint of the beauty within walking distance. Many trees and shrubs were removed to put in these lines. Civil engineer Maj. George Washington Whistler, the father of artist James Abbott McNeill Whistler, designed the railroad line from New Haven to Providence. The scene below is closer to the norm in the area. It shows the Black Hall School in Black Hall.

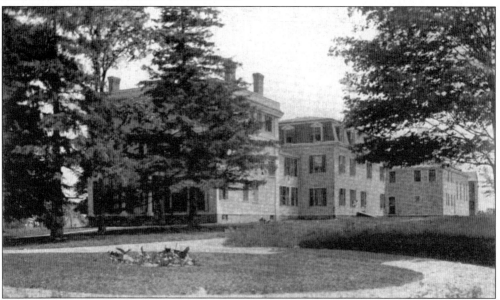

The Griswold name in Connecticut goes back to 1639, when Matthew Griswold, who had settled in Windsor with his brother Edward, became part of the Saybrook settlement under George Fenwick. Fenwick returned to England with his children, leaving Lady Fenwick's land east of the Connecticut River to Griswold, who farmed it and raised livestock. From the beginning, Griswold helped shape laws and regulations pertaining to land distribution and boundary disputes. He signed the articles of separation from Saybrook, representing the areas east of the river. Over the years, Griswolds have been prominent church leaders, lawyers, state legislators, and governors. Gov. Mathew Griswold (1714–1799) was a key contributor during the Revolutionary War. Today, Timothy Griswold is the first selectman of Old Lyme. Shown is the Griswold house.

The use of horses and oxen in the Lymes continued until quite late. Even in the last 10 years, residents could see horse-drawn plows being used in Old Lyme. Of course, blacksmiths had other business; several of them worked at the iron mills, creating pots and pans, farm implements, nuts, bolts, bits, and other useful items. Boats, wagons, houses, and even the early cars used blacksmith work until mass production and national distribution brought the end to the industry. The lovely road below, in Black Hall near the river of the same name, is typical of the atmosphere and look of the place even today.

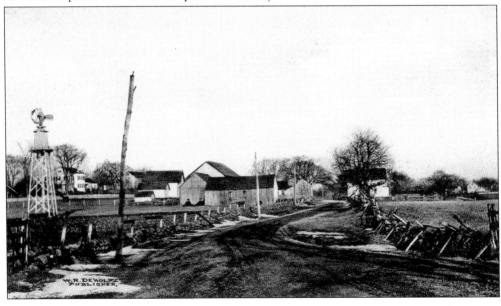

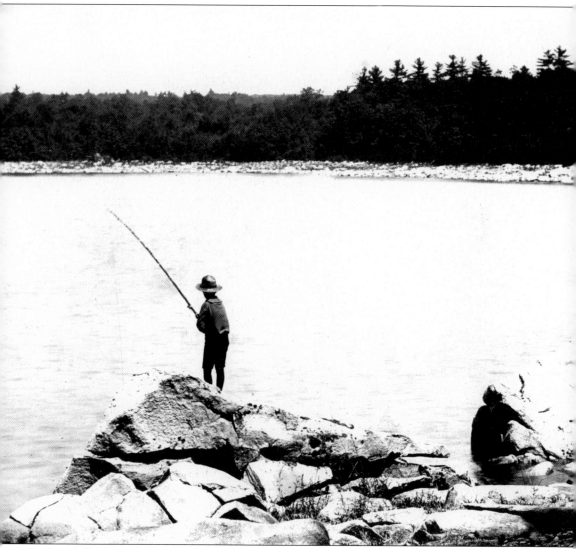

In this idyllic scene, a boy is enjoying a summer day on the rocky shore. The water along this area of the coast tends to be somewhat warmer than that in other spots. At the time this image was taken, many people thought that warmer water meant bigger fish. The picture was created from a lantern slide produced by a man from Willimantic named Whitmore. His family was in business there, but he spent the summers in the Lymes. The quality of these old glass slides is extraordinary by any standard, and the images are somehow more enchanting than others.

This property is at the end of Ferry Road. The stone ledge was troublesome for early farmers and held back development of many of the town's most beautiful places. Similar ledges are found nearly everywhere in the region. Remnants of the last ice age, they are often considered nature's artwork and are incorporated into house and garden designs.

Four

THE WEST SIDE
OF LYME STREET

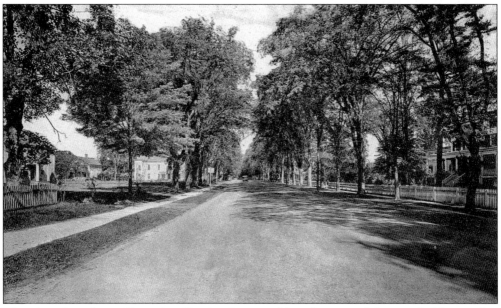

The view along Lyme Street is still a lovely one, although many of the grand old trees that provided shade for walkers and nesting spaces for birds were destroyed in the 1938 hurricane—and, of course, branches today must be kept trimmed away from electrical and telephone wires. A couple visiting a local restaurant was once overheard having this exchange. The woman asked, "You like the town?" Her husband replied, "What town?" This is a good observation. Nevertheless, there is a lot of life at the art academy, in the library, at the Griswold Museum, and among the talented people who paint, sculpt, write, perform on stage, and take photographs. Some say the area is for the birds. Ornithologist Roger Tory Peterson, who lived here, would have agreed.

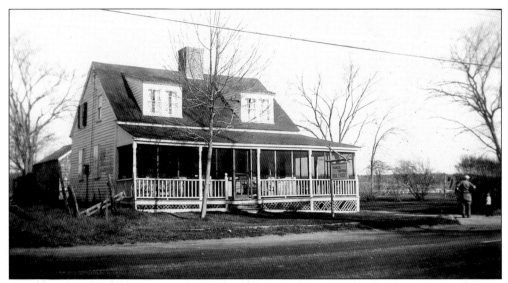

The house above stands just south of the firehouse. It is said that a member of the Ransom family occupied it at one time. The house below was built by Dr. Shubell Bartlett in 1844 on land purchased from Capt. Thomas Sill. Bartlett went to serve as a doctor in the California gold fields and died crossing the Isthmus of Panama. John Peck Van Bergen bought the property in the 1950s and named it Cricket Lawn. In the 1980s, it was the home of Rear Adm. Arthur G. Hall.

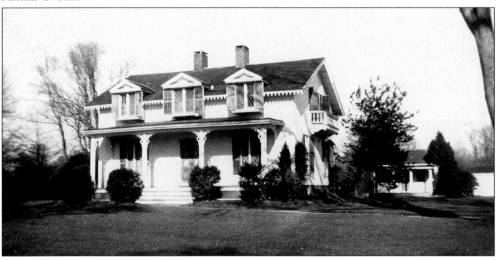

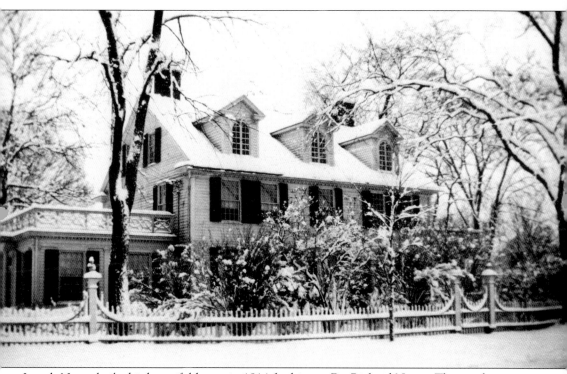

Joseph Noyes built this beautiful home in 1814 for his son Dr. Richard Noyes. The porch was added in 1910; rooms, dormer windows, and a wing were added in 1922. Over the years, the house has served as a home, a school for boys, and an inn.

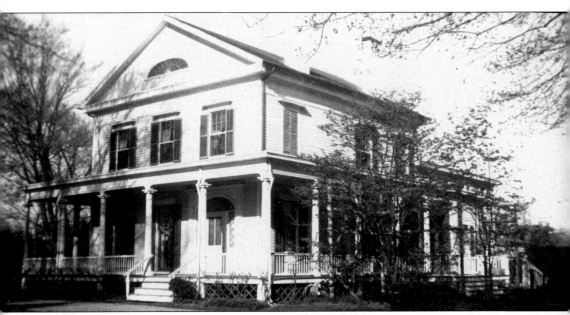

North of the home of Arthur G. Hall stands a house built by Capt. John Mather Chadwick, a well-known packet ship captain who sailed the Atlantic. According to Mary Hall James, Chadwick was the captain in James Fenimore Cooper's *Homeward Bound*. After the Revolutionary War, the Chadwick family assisted Lyme in recovering and growing outlets and sources for trade. The original flat roof of this house was raised after the hurricane of 1938.

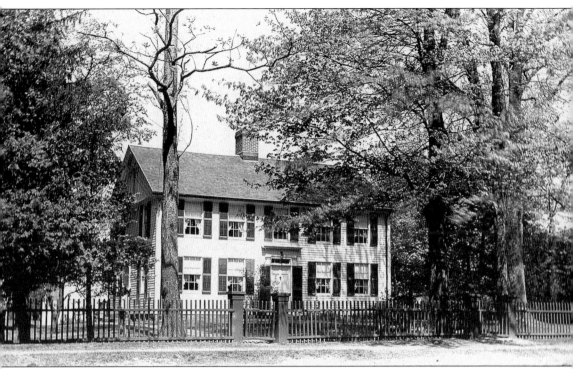

On the Ferry Road Corner across from the church stands the Stephen Peck house and the building popularly known as the Corner Store. Dating from the 1830s, the Peck house stands on the site of a previous house owned by the Peck family. The store is said to have been a recruitment office during the Civil War, and from its steps were read the latest bulletins from the front. It was torn down in 1939 after Mrs. Yeaw bought the property.

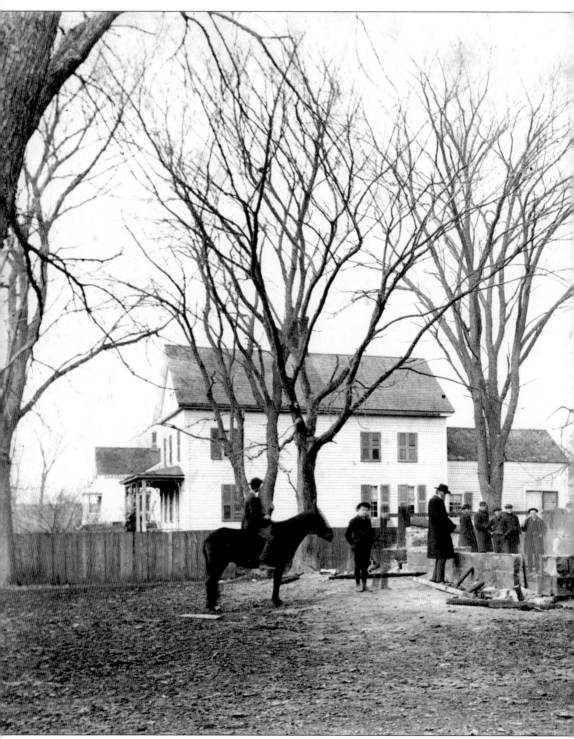

The Old Lyme Academy, long a secondary school for boys and girls, was destroyed by fire c. 1866. The Masonic hall was later built on the site. Directly north of the academy stands the Old Baptist Church, which dates from 1842–1843. Legend has it that some cannonballs were

found in the cellar of the church *c.* 1840. It was thought they were intended for use against the British in the War of 1812. This building has undergone changes, having harbored in succession three different congregations—the Baptists, the Episcopalians, and the Roman Catholics.

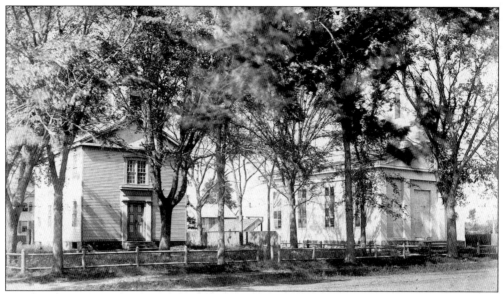

Old Lyme Academy is pictured above. Below is the Masonic hall, assembled on the site of the Old Lyme Academy, using pieces of the original town hall.

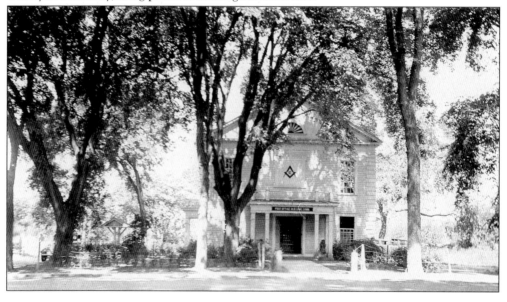

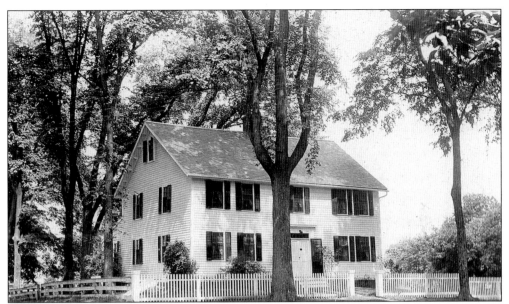

The Noyes-Beckwith House, at the corner of Beckwith Lane, was built c. 1700 by Samuel Peck on what is now the site of the Lyme Historical Society. It was purchased by William Noyes Jr. c. 1769. By 1816, it was considered too old to be of value and was offered to anyone who would remove it. A man named Tinker brought it to its present site. From 1872 to 1890, it was the home of Lyme native Morrison Remick Waite (born on November 29, 1816), chief justice of the U.S. Supreme Court. Waite was the son of Hon. Henry Matson Waite, chief justice of the state supreme court. The family has a long history of public service in the law. Thomas Waite was a member of Parliament and was one of the judges who signed the death warrant of Charles I, as was Col. George Fenwick, who oversaw the creation of Fort Saybrook before returning to England.

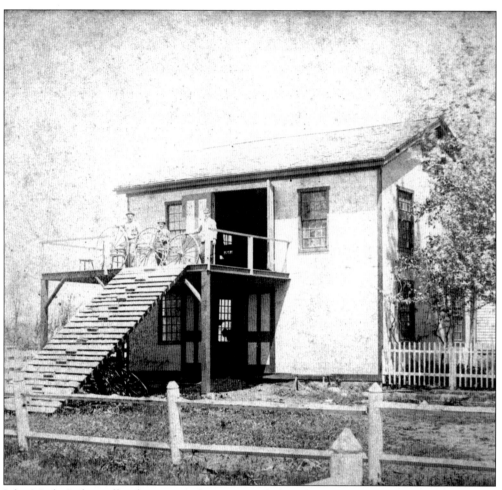

John Morley's shop offered a variety of services, including the repair of bicycles and the building of coffins and carriages. John Morley was typical of early residents, who were farmers first but were also craftsmen willing and able to do what was needed.

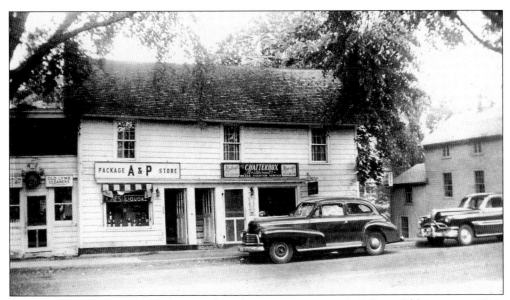

Although perhaps hard to believe today, there once was an A & P in Old Lyme in 1919. The company was testing self-service grocery stores and had what must have been among the first shopping carts. The building was originally constructed as a drugstore but was then leased to A & P for a few years. W.L. Clark's wagon delivered groceries in 1895. Horse-drawn buggies were still a common sight. The post office used them, and so did the meat market and other provisioners.

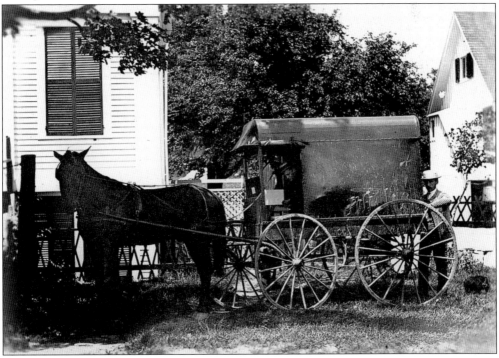

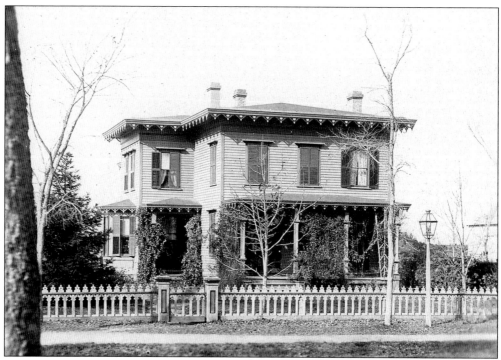

This house was built for James A. Rowland in 1880. In 1978, it became the rectory for the Catholic church.

The Charles Morley house was built c. 1800. For some time, there was a tannery in the meadow in back of the house.

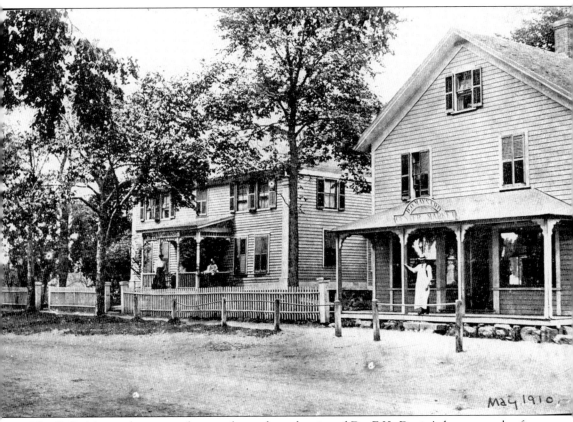

The D.O. Maynard meat market was located on the site of Dr. E.K. Devitt's house, south of town hall.

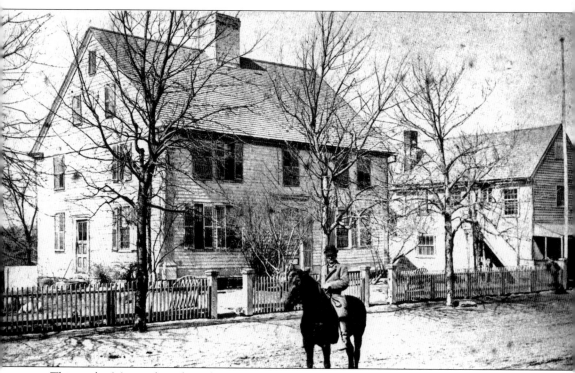

This is the Maynard market after Roger Pierson, looking rather dapper in the picture above, bought it, moved it to Sill Lane, and made it his home in 1910. Unfortunately, the building burned in 1915.

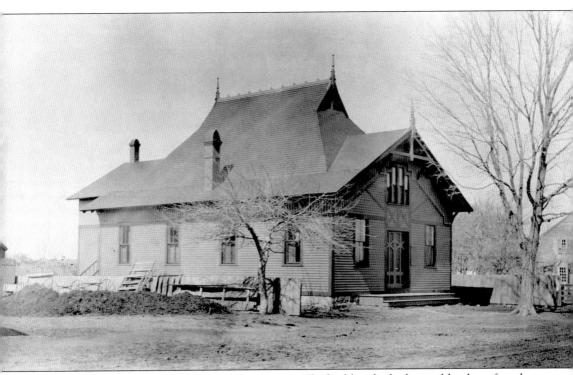

The design of the old town hall was very interesting. The building looked more like those found in Scandinavia or the Cantons of Switzerland than those in Britain or early America. In this view the town hall, with its extremely slanted roof, looks ready for the heaviest snows.

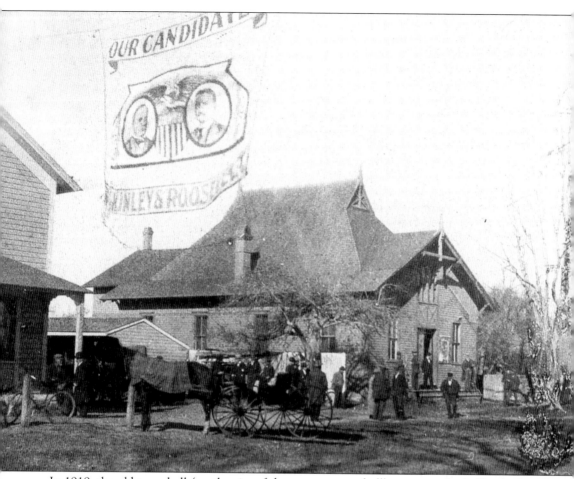

In 1919, the old town hall (on the site of the present town hall) was moved a half-mile down the street to the site of the burned Old Lyme Academy. Herman Hubbard purchased the old building and presented it to the Masons for a hall. The move caused great excitement in town and was photographed by all. The move was a real team effort that called for strength and cooperation. The local builders were old hands at moving buildings, which had begun very early in the town's history. Reusing houses, parts of houses, churches, or public buildings simply made sense. The workmanship that went into the original structure, obviously, was good enough to hold everything together and get it safely to its new home in good shape. It did, once again, in this case.

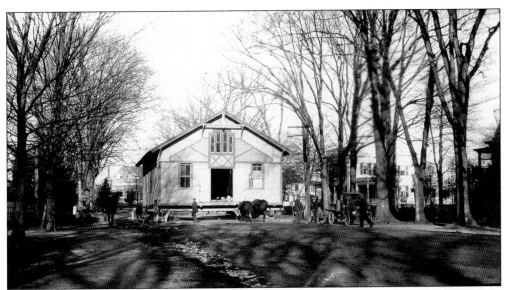

The move was only a half-mile, but everyone worked hard. Today, houses occasionally pass along the highway, going from the factory to the site. In the early days of the Lymes, houses that had been lived in for quite a while were considered moveable or alterable as a matter of course. Built of high-quality materials, they were made to last beyond the present generation and were often assembled by men who came from a shipbuilding tradition. Barns were built with the same care. Hardwood floors, plaster walls, and expert joinery were the norm. Attention to quality details has resulted in a lasting inheritance for those who hope to conserve and preserve treasures of the past.

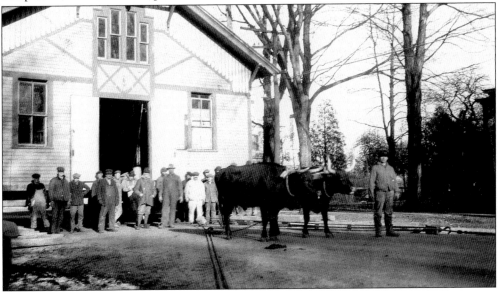

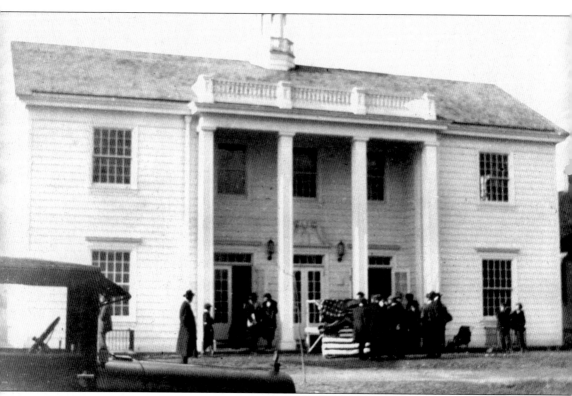

The Memorial Town Hall was erected in 1920 at a total cost of $40,000, of which $25,000 was appropriated by the town and the balance raised by popular subscription. Its appearance today is enhanced by the mature trees and plants surrounding it. The building is a memorial to the the Old Lyme men who served their country in time of war.

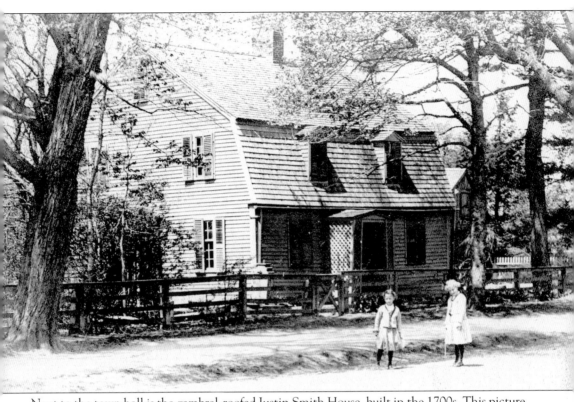

Next to the town hall is the gambrel-roofed Justin Smith House, built in the 1700s. This picture shows the house prior to a renovation done by Mrs. Henry Day in 1986.

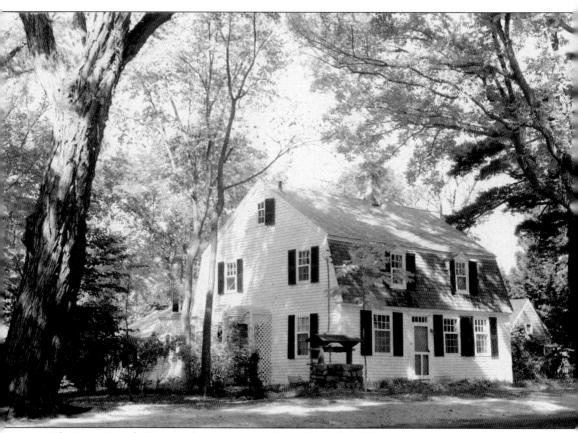

The Justin Smith House, after renovation, is looking splendid.

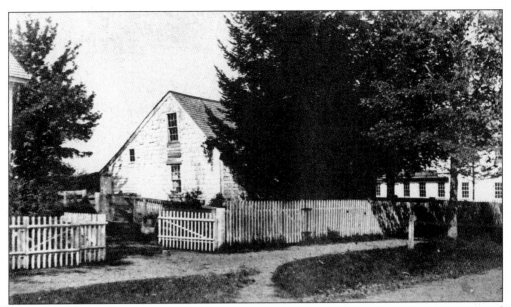

Next to the town hall was the old Higgins-Lay house (above). Torn down between 1890 and 1900, it was replaced by the James F. Bugbee house (below), which was made from several old buildings. Undoubtedly, some parts of the original house were reused, as this was the custom.

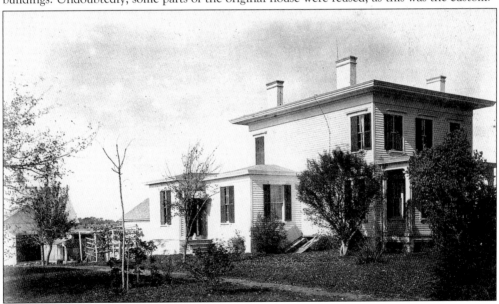

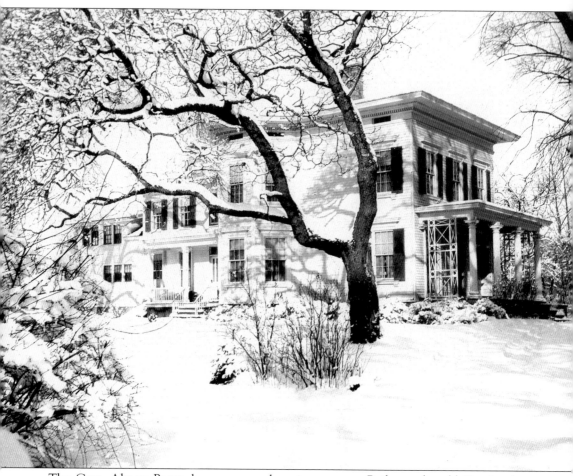

The Capt. Almon Bacon house was a charming cottage. Built on the old Deming house property, it was owned by artist Charles Ebert.

The Avery House is a quaint gambrel-roofed structure dating from c. 1726.

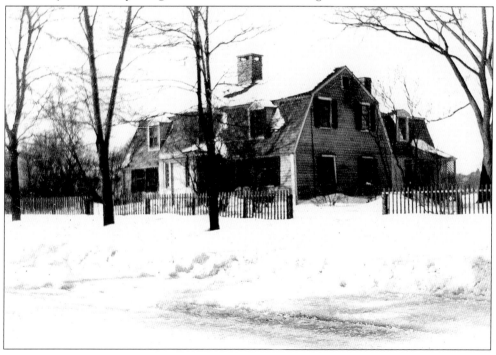

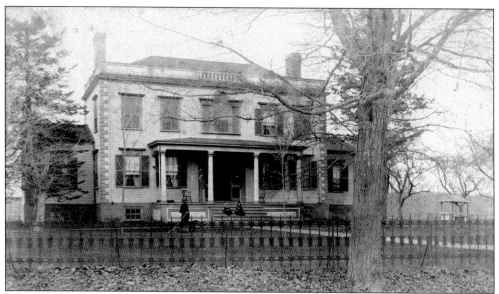

This beautiful building was the home of the Davis family. In addition, on the corner of the property, was a square brick structure with iron bars on the windows. Known earlier as the Hull House, it was built in 1812, a date that may provide a clue to the need for the bars. During that time, the region was attacked by the British, who made exploratory excursions for food and supplies while traveling the Long Island Sound. It is believed that the structure was originally built as a house with a store by a Noyes family member. The family name Noyes was burned into the woodwork. In 1948, this and the preceding house were supposedly destroyed to make way for the Route 95 overpass. However, it could be that the Davis and Sill houses are one and the same, with only minor alterations and restoration.

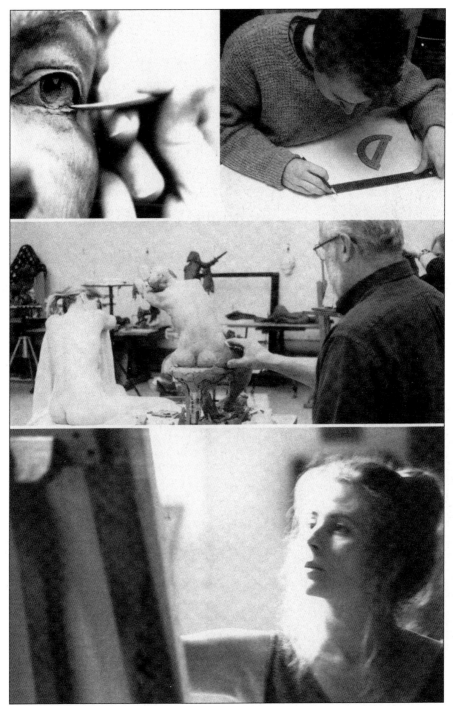

The Lyme Academy College of Fine Arts was founded on the idea that a liberal arts education opens the eyes and awareness of students, allowing them to draw on a wealth of sources beyond their own personal experience. The goal is to produce individuals who are "literate, articulate and as deeply engaged in intellectual and social pursuits as in the mastery of craftsmanship," according to Henry E. Putsch, former president.

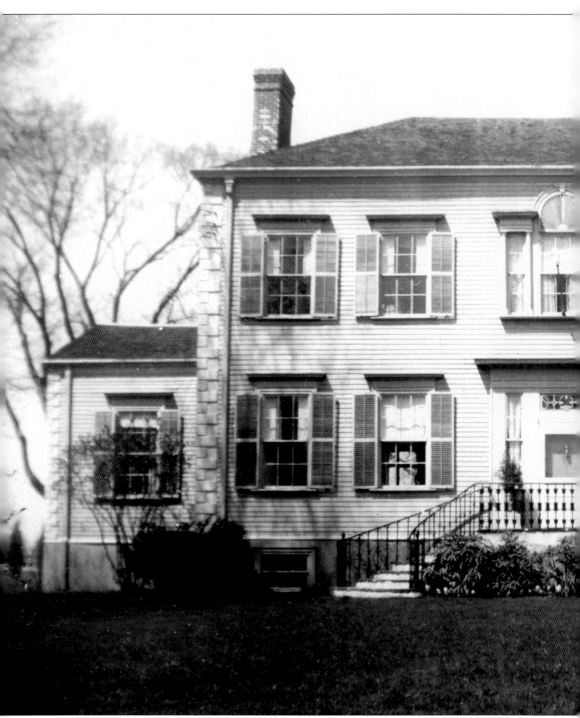

The John Sill House dates from 1817 and was designed by Col. Samuel Belcher, architect of the Old Lyme Church. The carpenters were boatbuilders, and the frame is beautifully put together with fitted oak pins. It is owned today by the art academy and is part of a new expansion celebrating the recognition of the Lyme Academy College of Fine Arts. The

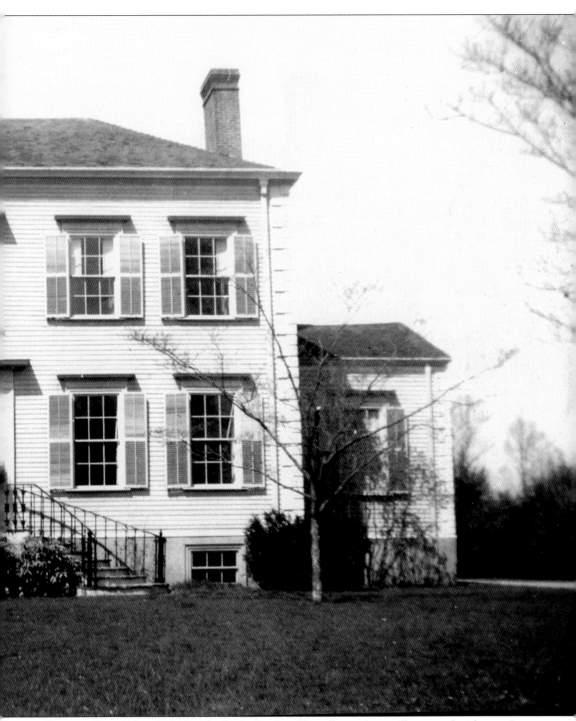

academy was founded in 1976 by Elisabeth Gordon Chandler and a small group of art lovers. It was envisioned as a place where the study of visual arts would be based on classic disciplines. On September 1, 2002, Frederick S. Osborne became president of the academy.

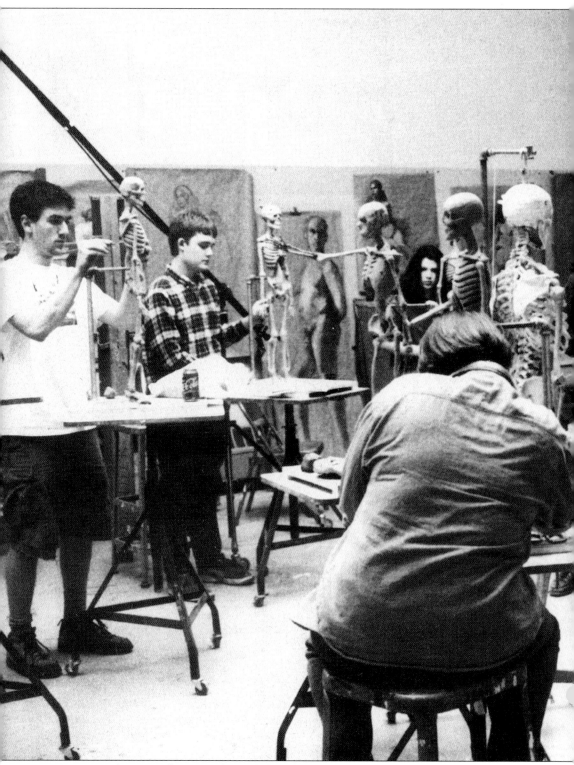

Anatomy class was where one learned that the old song was right; the neck bone is indeed

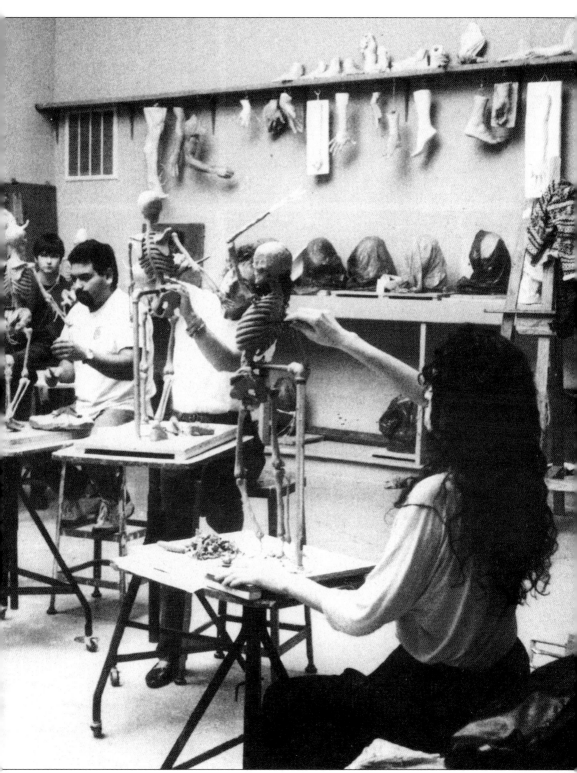

connected to the head bone.

Only 25 years ago, few people would have believed the universality of computer applications in the arts today. The computer is a vital component of education, allowing access to collections at a closeness no museum guard would allow. One can research the piece of art and its creator. Nevertheless, nothing equals standing in the presence of a work of art.

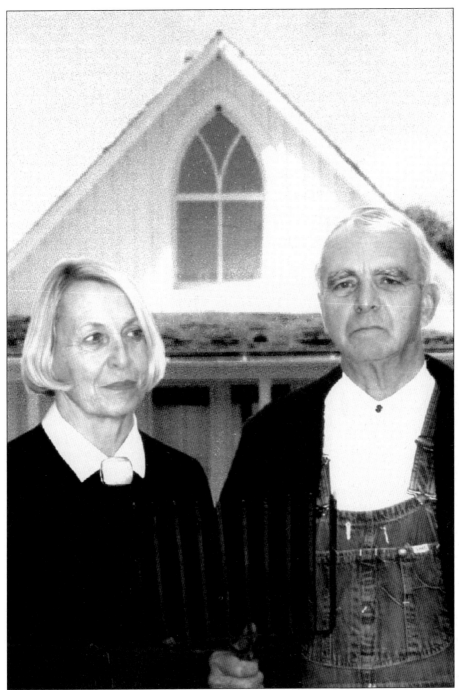

Bob and Carol Schneider pose in their version of Grant Wood's *American Gothic*. The image, sent out as a personal card, epitomizes the attitude at the Lyme Academy College of Fine Arts—serious about art but looking at the world with humor and connecting to the people in it. Bob Schneider later resigned from the board but continued to work for the academy on a part-time basis. You might say that people do not leave the academy; they just change their perspective.

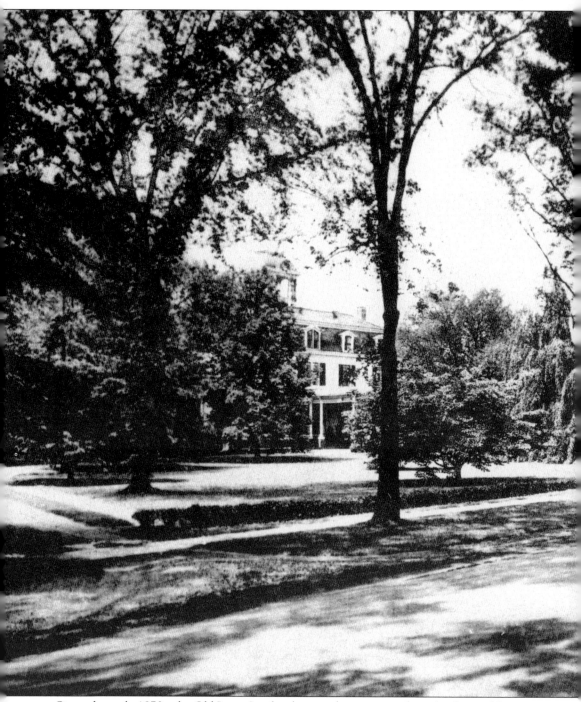

Since the early 1870s, the Old Lyme Inn has been welcoming people with a beautiful exterior, a warm and charming interior, and delicious food. Woodrow Wilson, Theodore Roosevelt, Sinclair Lewis, Alf Landon, Lillian Gish, and Prescott and George Bush are just a few of the

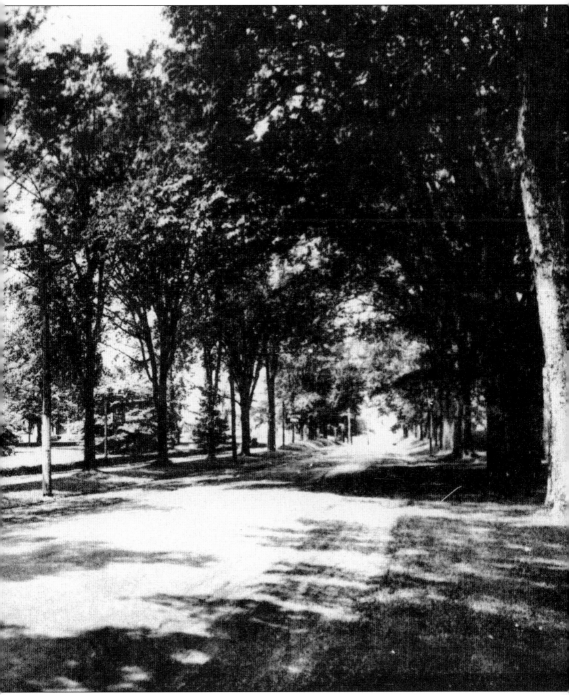

many notables who dined or stayed here. Many of these trees were lost in the 1938 hurricane, but it is still a beautiful street.

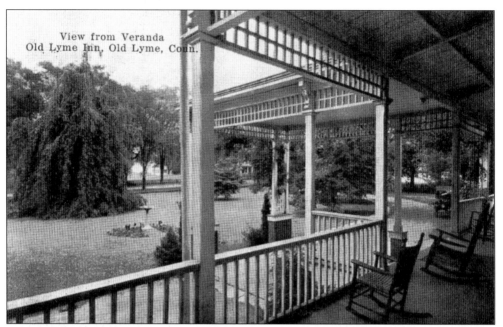

View from Veranda
Old Lyme Inn, Old Lyme, Conn.

In this incarnation, built in 1970, the essence remains. One of the things mentioned in awards given to the Old Lyme Inn by newspapers and magazines is the lovely building. Below is the Lyme Art Association Gallery.

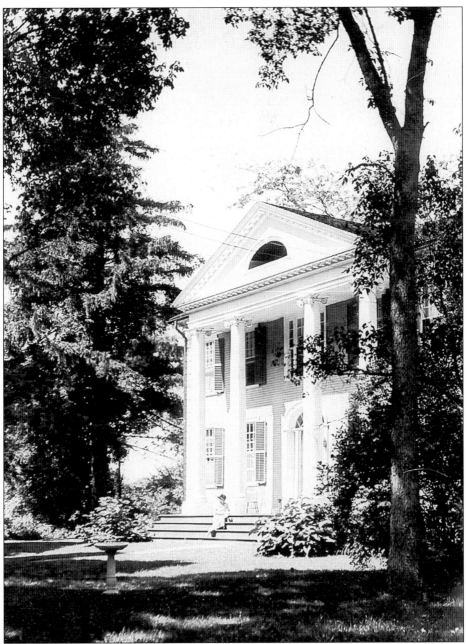

In a variety of media, many famous artists have tried to capture the image of Lyme and the surrounding countryside. They started coming into the area in the 1880s in great numbers. Many stayed at Florence Griswold's boardinghouse, run by a wonderfully eccentric woman who was the daughter of a sea captain and granddaughter of Gov. Roger Griswold. When her father died, Florence Griswold opened her doors and her heart to the young artists (many from New York) and created what was to become a mecca and showcase for the American Impressionists. She was never financially successful, but she lived a long and fascinating life. Through the generosity of people who appreciate what she did and what the artists created, her house has been restored into something that would have made her smile.

Just north of the Lyme Art Gallery stands the Florence Griswold Museum, the home of the Lyme Historical Society. This building was the William Noyes house, built in 1817. The stately

old mansion was designed by Samuel Belcher. It was here that the Lyme Art Association began and flourished. Shown are early members of the organization.

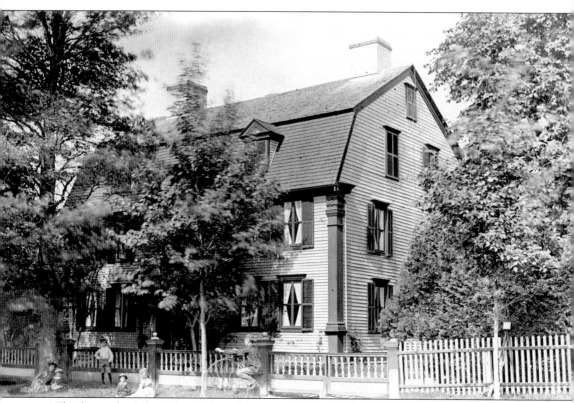

This house, built for Judge William Noyes *c.* 1790, was a fine example of Colonial architecture. Noyes was the grandson of Moses Noyes, the first minister in Lyme. He was born in 1760 and graduated from Yale in 1781. Along with Matthew Griswold, he attended the meeting in Hartford that supported and ratified the new Constitution. In 1777, Noyes was a member of a committee that was chartered to supply necessities to the families of volunteers in the service of the country. The committee also voted to punish anyone who took advantage of the war and limited supplies of basics to raise prices; an offender was made a public example of for war profiteering. The house later became the Bee and Thistle Restaurant.

The Noyes house was moved back 100 feet on the property, creating a semicircular drive and affording privacy from an increasingly well used road. Porches and a wing on the rear section were built, and extensive interior work was done. The beautiful barn, called the Sabine Barn because Bishop Sabine had occupied the house for a period, was also moved back and was used as a cottage.

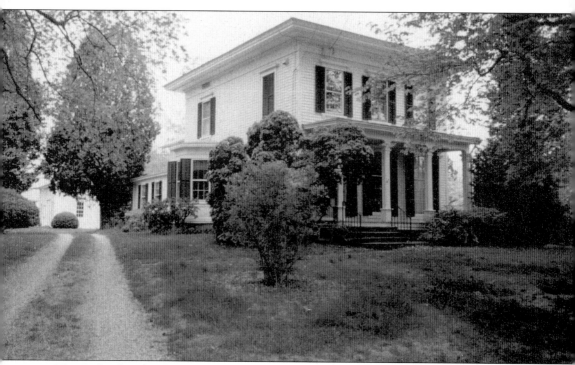

The Richard Noyes house, built in 1756, was purchased by Richard Noyes's cousin William Noyes Ely in 1866. It was the home of Susan Hollingsworth Ely and is still in the Noyes family. John Noyes, Susan Ely's brother, was a forester for the government and taught environmental forestry at Amherst. After he saved a forest from arsonists, J. Edgar Hoover sent him a letter of commendation. The Noyes family is a key supporter of Old Lyme and its educational resources. When the Sabine barn was disassembled, part of it was joined to the barn already on this property. Parts of the barn are more than 300 years old.

The Old John Peck Tavern faces south down Lyme Street at the fork of Sill Lane and Laysville Road. It was built as a tavern in 1769 by John Peck. The tap room is on the left as you enter. The parlor, on the right, has tombstone paneling. On the second floor is a ballroom with a swinging partition. For generations, the room served as a social center and was the scene of many balls. John McCurdy operated a store in the building, and at that time it was the only store between New London and Guilford. During the Revolutionary War, it was a center for distributing food and clothing to passing soldiers, as well as to the families of local men away in the service.

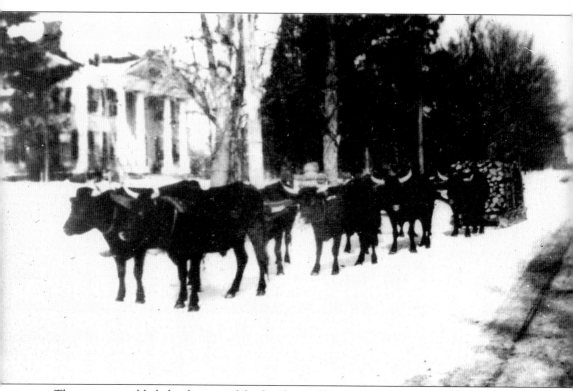

These oxen are likely hauling wood for fireplaces. They are headed past the Florence Griswold house, probably having picked up their load farther toward Rogers Lake. It is easy to forget when looking at these beautiful homes that insulation was primitive and central heating was unknown.

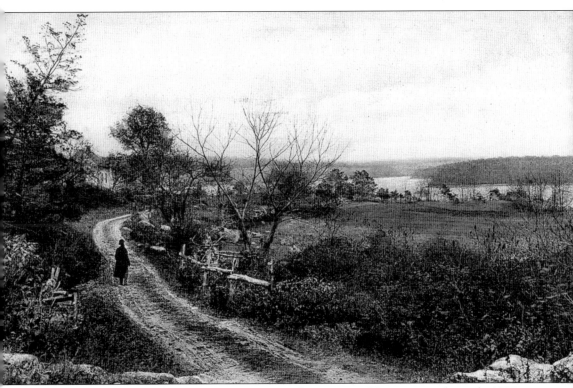

Today, hiking and trailing for recreation are popular pastimes. However, in the early 1900s, when this picture was taken, walking was still the way people got from one place to another. People would walk eight or ten miles to attend church in unheated buildings and return home the same way. Some had horses, but youngsters and grandparents walked. "The salty, bracing atmosphere tends toward the increase of mental vigor as well as length of years," an article on Lyme in an old *Harpers Monthy* states.

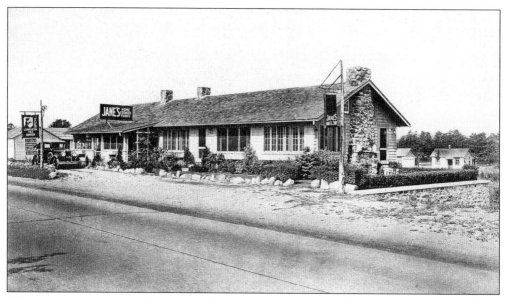

These two businesses sat on the Boston Post Road, practically on the lakefront. The waffle shop was a great place to stop for breakfast and a favorite local place to meet friends. The Lake Breeze Inn building is now a private residence. Rogers Lake feeds into a branch of the Lieutenant River. That branch, Mill Brook, was where many mills were built, and it was a source of trade and money for the town and its people. Although only four and a half miles long, the branch was a vital part of the community.

Rogers Lake is shown as it appeared before development. This is the heart of the area on the Boston Post Road. At the Laysville store, renovated in 2003, people can find tools and paint, and coffee and doughnuts—all in one stop. Nearby are gas stations, a laundromat, two restaurants, a senior center, and other conveniences.

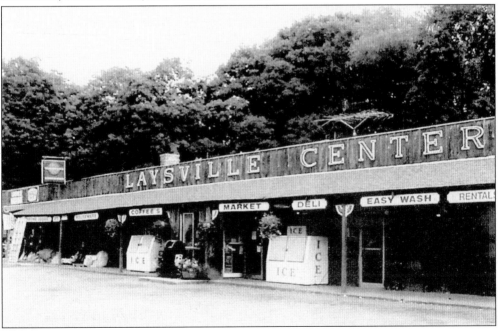

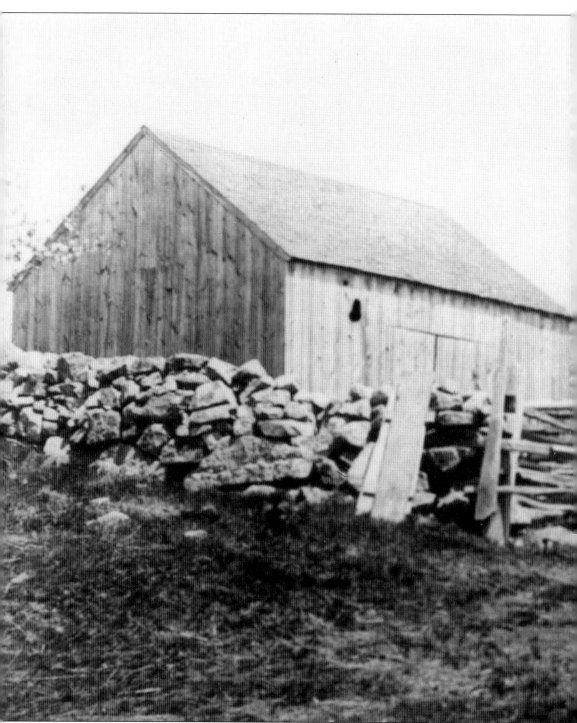

Work was simply a part of life on the farm in the early days. When the first schools were assembled, classes were held for only three months a year, during a period when everything was comparatively quiet on the farm. Even after the school year was extended, children were

excused if they were needed on the farm. This photograph, taken in Lyme, shows Mr. Coit with an unidentified child.

Artist Will Howe (right) was famous for painting charming pastoral scenes that included cows. He was part of the American Impressionist artist colony that later created great interest in Old Lyme. Here, he watches John and Richard Noyes cutting ice out behind the Griswold Museum in the 1920s.

Penny Rock was so named because in the 1930s, these large rock outcroppings on the McCurdy property would contain hidden pennies for the neighboring children to find. It was a simple but delightful thought.

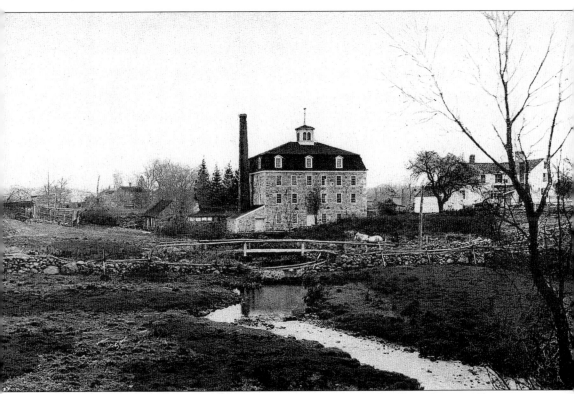

This marvelous old mill was made entirely of stone. Known as the Bradbury Stone Mill, it was built by Oliver I. Lay from 1839 to 1840 on Sill Lane. In it, Lay produced textiles, ran a dye house, and made cloth and yarn. John Bradbury was a wool scourer until the 1870s, when he leased the mill along with a building in which to house employees. He set about producing dyed and finished cloth and yarn. He bought the mill in 1880, only to lease it shortly afterward to the Lyme Silver Plating Company. Other companies owned the mill, but in 1958, Richard French (a well-known antiques dealer) remodeled it into a residence, which it remains today.

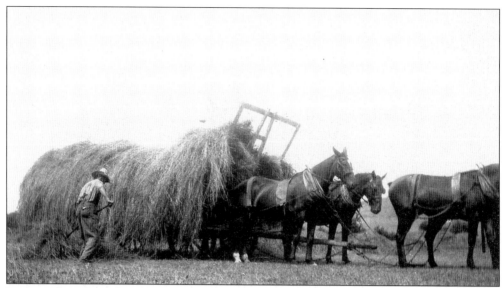

In the earliest days of European settlement in this area, a person who acquired a parcel of land would also be granted use of salt hay fields. In East Lyme, Black Point was a favored area. In the other Lymes, there were many areas to choose from, including the Lieutenant River, Black Hall River, Eight Mile River, and just about anyplace known as "the meadows."

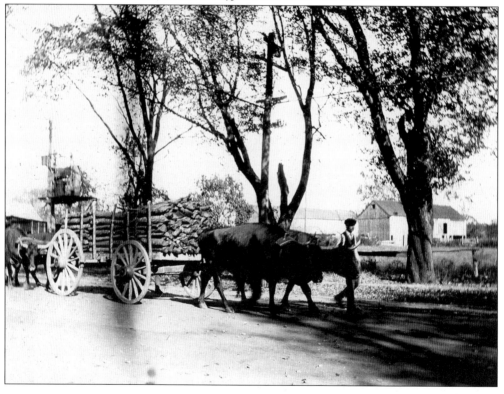

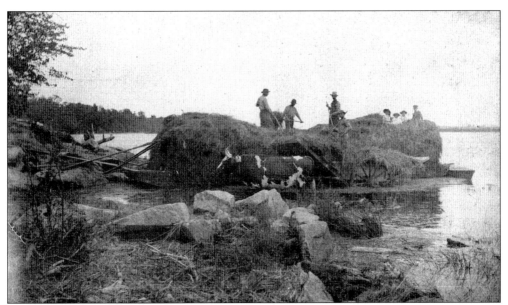

Salt hay was a valuable commodity. It could be used for animal bedding and then be spread out later as fertilizer, since the seed would not "take" outside the meadow conditions. The hay was moved by cart. Some was brought to scows so it could be shipped where it was needed. This was hard, hot work and took teamwork, as did most big jobs before the advent of mechanized machinery. The hay was used for oxen, horses, and sheep. In fact, Lyme was once home to more sheep than anywhere else in Connecticut.

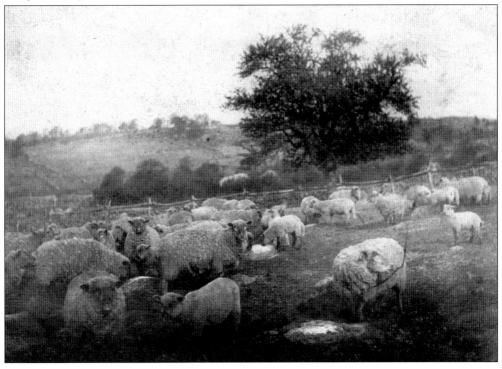

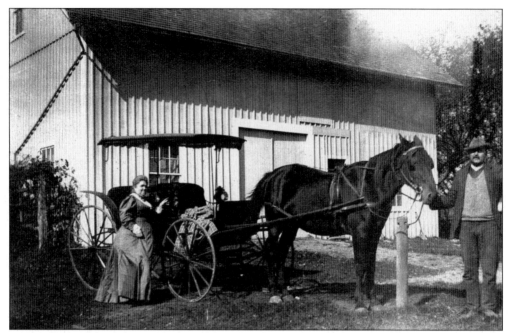

Above, a woman identified as Mrs. Chapman is setting out on an excursion. Below, members of a charming family are doing the same. Although their names are not know, they are certainly handsome, and their carriage is fine.

An unidentified man is shown with a pony at the Hamburg Fair. The man certainly looks proud. Perhaps he won a prize that day.

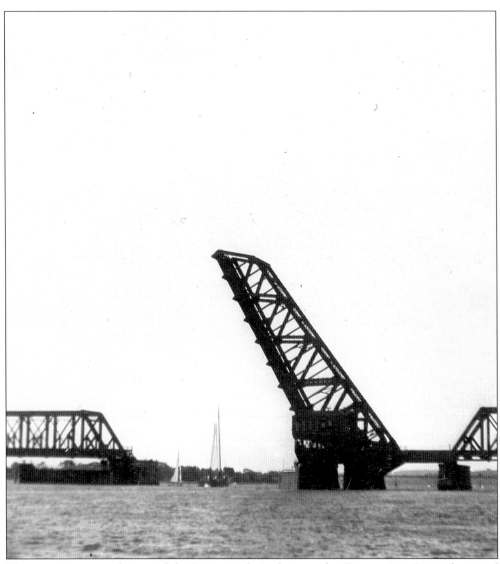

The most important feature of the Lymes is their place on the Connecticut River shore and the coast of Long Island Sound. Over the centuries, the location has provided industry, personal adventure, and a unique place to live. While most of the images in this collection show scenes and houses that have been conserved, these pictures are of boats, the likes of which will never again be seen.

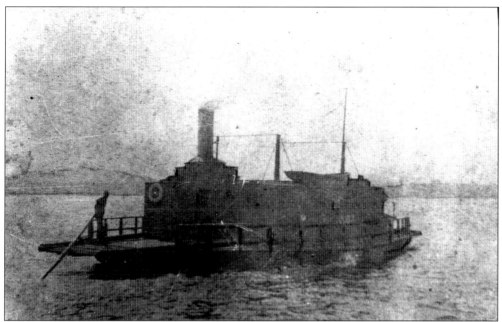

Unlike the wooden beauties
re-created by enthusiasts today,
these vessels are primarily
simple working boats. Such
boats no longer exist in
this area.

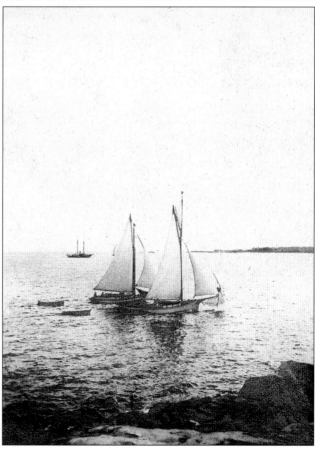

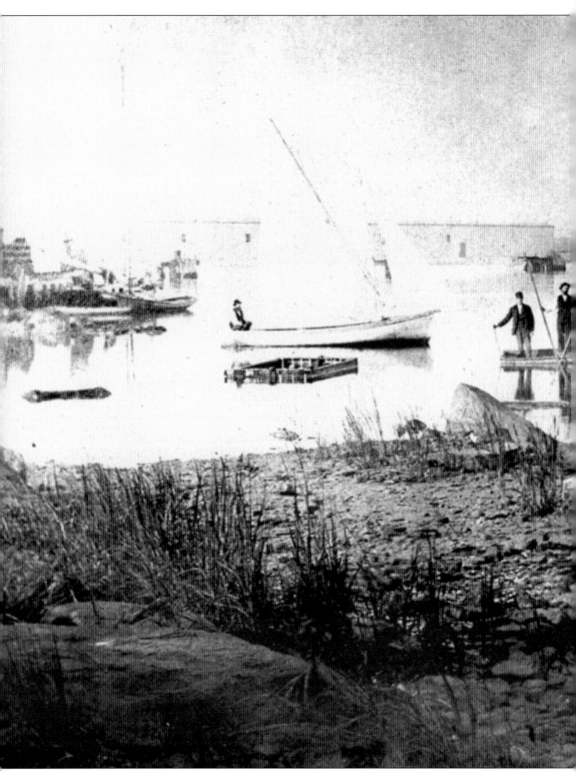

These men seem to be waiting for a big boat to arrive. The photograph has an artist's touch.

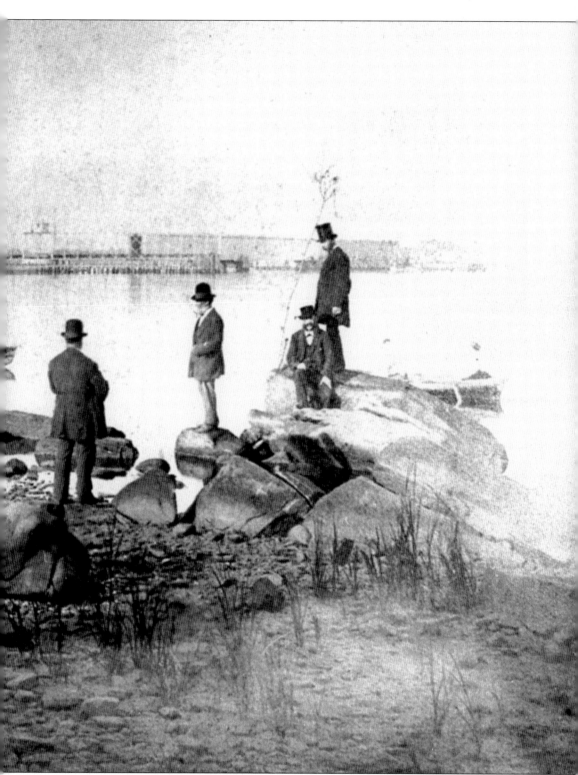

The scene could not be more interesting if had been staged. It is Old Lyme in the 1880s.

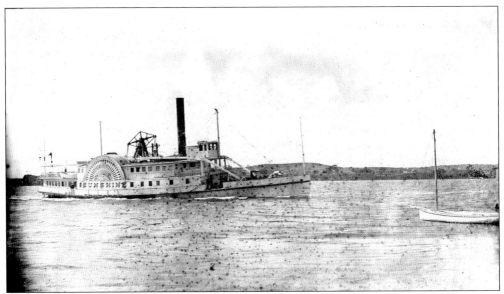

This big wheeler went up to Hartford, stopped at Glastonbury, Middletown, and Old Saybrook, and continued on to New London and Stonington.

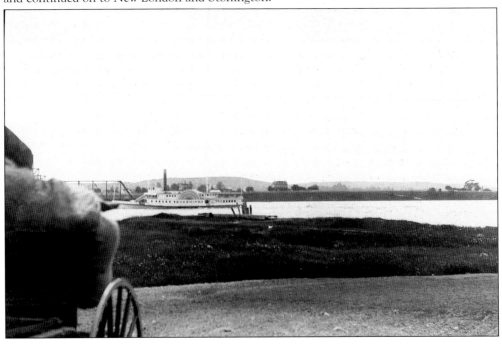

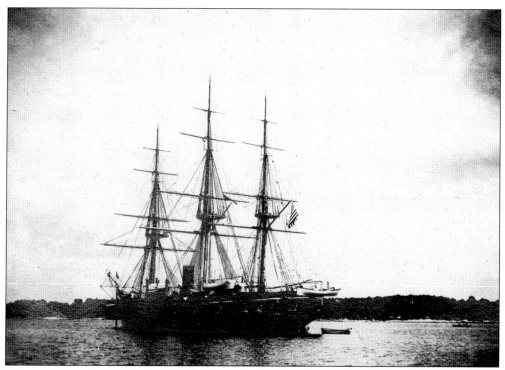

These images show three-masted and two-masted schooners. Steel replaced wood in boatbuilding in the 1880s. Later, fiberglass was used. Today, there has been a resurgence of interest in the wooden boats, but these shown are long gone.

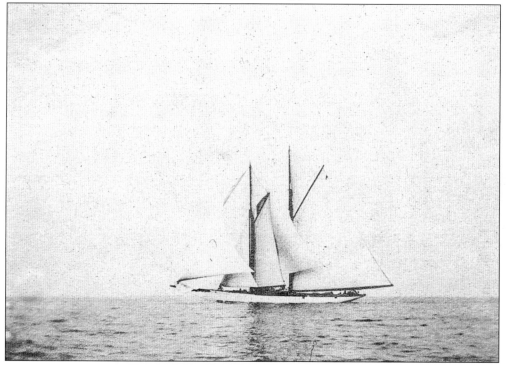

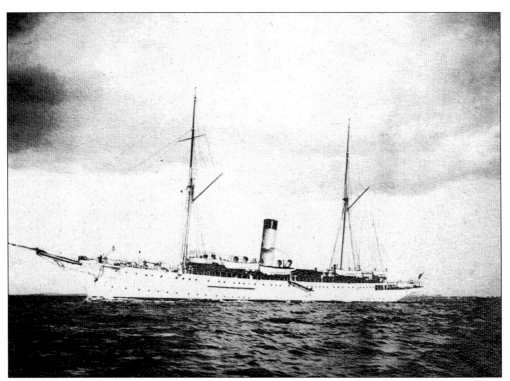

The great-looking boat seen above reminds one of a man wearing a belt *and* suspenders. Even from this distance in time, it looks ready. Below is a sunset.

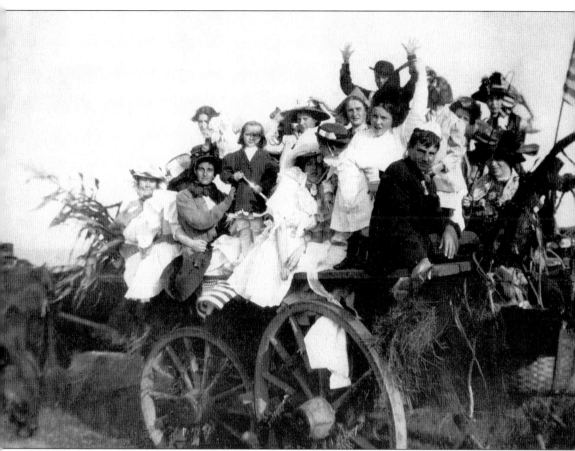

The people in this late-1890s view are off to a party, probably a local celebration marking the end of the farming season.

ACKNOWLEDGMENTS

My thanks go to John and Werneth Noyes, the late Susan H. Ely, Elizabeth Plimpton, Jen Hillhouse, and Diana Atwood Johnson for the use of their images; to Elizabeth Putnam for her pictures and stories about Brockway's Ferry and her wonderful father; and to Ron Martel and his magic wand for the scanning.

BIBLIOGRAPHY

There are many excellent sources of information on the Lymes, including the state archives and the Shaw Mansion in New London. Written works used in preparing this book follow:

The Educational History of Old Lyme, Connecticut (Yale University Press, 1939), by May Hall James.

For the Love of Books (Hull Publishers), by Alma Merry Tatum.

Hamburg Cove, Stanley Schuler, ed. Lyme Historical Society.

Lyme Connecticut: From Founding to Independence, by Bruce Stark.

A Lyme Miscellany, 1776–1976, George J. Willauer Jr., ed.

Lyme Yesterdays: How our forefathers made a living on the Connecticut Shore (Pequot Press, 1967), by James E. Harding.

Miss Florence and the Artists of Old Lyme (Pequot Press, 1971), by Arthur Heming.